Living With Lincoln

Living With Lincoln:

Life and Art
in the Heartland

Dan Guillory

Stormline
1989

International Standard Book Number: 0-935153-11-X

Library of Congress Number: 88-061678

Stormline Press, Inc., a non-profit service organization, publishes works of literary and artistic distinction. The press is particularly interested in those works which accurately and sensitively reflect rural and small town life.

Stormline Press, Inc.
P.O. Box 593
Urbana, Illinois 61801

Manufactured in the United States of America.

The author wishes to thank the editors of *Illinois Times,* in which these essays originally appeared.

Publication of this book is made possible in part by a grant from the Illinois Arts Council, a state agency.

Dedication

To My Mother and Father

Contents

Preface

These essays owe their existence to an extraordinary interval in my life. For some nine months I lived a double life as a Fellow at the University of Chicago and a rural homesteader in Shelby County, Illinois. On weekdays I inhabited a high-tech apartment in a tall skyscraper overlooking the shores of Lake Michigan. On weekends I drove a battered pick-up truck 215 miles due south and re-discovered my second life as the restorer of an antique prairie house, erected over three-quarters of a century earlier. Here, my inevitable companions were quail, deer, pheasants, farmers, hunters, and fishermen—all standing in an unconsciously beautiful world of forests, lakes, fields, and hedgerows. Every Monday I dutifully returned to the densest neighborhoods of Chicago, continuing my government-sponsored research on technology and the humanities. In fact, the first four essays (in order of composition) still bear the marks of this double life ("Bel Air: The Automobile as Art Object," "Shadows," "Illinois 128," and "A House in The Country").

Anything looked at long enough—or in the right frame of mind—can be elevated to the special status of art. The old Illinois prairie, with its glacially flattened horizons and great, smoldering sunsets, offers abundant proof of this first principle of aesthetics. I would have missed all—or most—of this beauty if it had not been for the redeeming influence of the poetry of John Knoepfle and Lucien Stryk. Their voices spoke poignantly.

Most of these essays originally appeared in *Illinois Times,* and in such publications as *Michigan Quarterly Review, Rural Life,* and *Illinois Issues.*

I thank the editors of those publications for permission to re-print the essays in this form. I also thank the Council on Faculty of Millikin University for grant money that helped to underwrite most of the costs of travel and interviewing. An immense debt is owed to Mrs. Helen Nelson, who kindly volunteered to type the original manuscript and to put it on computer discs. One of my students, Ms. Julie Beamer, performed a superbly professional job of proofreading the manuscript. To my wife, Leslie Tanner Guillory, and to my daughter, Gayle Marie, there is owed

the special debt that only a husband and father can hope to repay. I feel their presence on nearly every page.

I offer these writings now because the Heartland is under more scrutiny (and, perhaps, more peril) than ever before, largely because of unpredictable, global economics and ever-increasing foreign intervention. As a native of the Cajun country of southern Louisiana, I struggled for many years to learn the language of Illinois—and I refer not merely to spoken dialects but to the deeper resonances of the heart. And I have tried to reproduce the most telling of those utterances.

—Daniel L. Guillory
Findlay, Illinois
November 1987

Illinois 128

The field rows flash by like stroboscopic blips, streaks of light beating a soft pulse at the edge of sight. In other places you use a map to get from here to there, but central Illinois *is* a map, a giant flood plain as flat as a table top. On a good day in late fall or early spring, when the whole countryside is parchment-colored and the wind scrapes through the bean and corn fields, you can see how every line holds perfectly true.

Field lines and county lines, property boundaries, even the placement of barns and cowsheds follow the inevitable directions of the surveyor's telescope. North/South, East/West—we either follow the sun or directly oppose its transit. In no other place is the world so organized and fitted into discrete and recognizable parts so that fields, ditches, silos, barns, and railroads obey the sun with the fidelity of an Egyptian pharaoh. Nothing is out of place; nothing stands or grows unless it belongs. Billboards simply do not exist, and roadsides are scrupulously free of trash and litter.

This cleanliness and mathematical organization of space combine to make central Illinois a driver's delight. Straight-arrow roads and unobstructed vision allow one to see everything and go anywhere. On snow-covered days in February when the earth is crusted with ice, upright weeds and posts and limbs stand out in nakedly sharp relief. The red-tailed hawk is revealed down to the wrinkles of his taloned feet. The old wooden barns, those noble, shiplike presences, are cut into place in the blue jigsaw of the sky with the sharpness of an exacto blade.

I drive old 128 every day, and the movie is never the same. By late November the fields will turn black as soot, after harvesting and discing are done. Then come the freezing rains and snows, with occasional blizzards that reduce the highway to one icy lane threading its way between drifts. In mid-summer this same road becomes a tunnel through some of the most productive land on the planet. One hundred and forty-five bushels of corn per acre is a common harvest. On a fine, frosty morning, I'll drive by a field and see a huge green combine poised like a dragon, ready to

1

devour the gold. When I return that evening, all that remains is black earth. The overwhelming feeling one receives isn't a sense of individual objects but of things appearing and disappearing in space, under a high-domed, three hundred-and-sixty degree horizon.

There is no surer proof of the beautiful passage of things than the sunsets on that prairie horizon. They can glow like embers for three hours or more before extinguishing themselves. They can bathe the snowfields in lilac or pink. Magenta, slate blue, peach, and wine are poured in striations that seem to run from Wisconsin down to the Ozarks. Silhouettes of windmills and cedar trees stand in the last light the day can offer.

The only other action is the puppetry of clouds, like ink-blots suggesting a variety of animals and other shapes. One evening I watched the flight of a fine goose, a creature some two counties long. And recently I raced an old locomotive, both of us hurrying, as we always do, to make it home before sundown.

Goodbye, Proud Barns

I first saw Illinois from the window of a bumpy little turboprop that was flying due south from O'Hare. The weather was gorgeous, one of those glassy blue days in early November when the horizon stretches for hundreds of miles and even the smallest features of the landscape stand out like the details of a perfectly focused photograph. A few hundred feet below me the prairie assembled itself into a splendid patchwork of black, tan, and golden fields, all bounded by razor-sharp blacktop roads. Only the meandering creeks had escaped the strict linear plotting of the township surveyors. The neatness of the whole scene reminded me of a giant floor or a board game, and the grand old barns—at my altitude—resembled the little wooden hotels of my childhood Monopoly game. Those peaked red buildings gave a definition and character to the scene that has stayed with me ever since.

I can be dropped anywhere in the Midwest or in the eastern half of the U.S. and orient myself by the style and design of the local barns. I've seen the stone barns of New England, the hex signs on stone and wood barns in Bucks County, Pennsylvania, and the hulking white barns of Wisconsin's dairy country. But my heart goes to the red barns of Illinois, which are lovable in their largeness and simplicity. I put them in the same class as big dogs, ships, mountains, and other monumental things. But of these only the barns are disappearing from our midst, and by the turn of the century the Prairie Barn will certainly be a rarity—if it has not become extinct. I take a few moments now to sing its praises because it will probably vanish in the not-too-distant future.

Barns were a basic component of agricultural society in a vast, continental expansion that took us, as a nation, from the rocky outcrop-pings of coastal New England to the broad prairies of the heartland and beyond. Barns became the focal point of animal-powered agriculture, a parking place for grain wagons and plows, and a home for horses and cows, especially during the bitterly cold winters. The upper parts of barns provided spacious lofts for the storage of hay, while the ground level was

3

subdivided into practical grain bins and animal stalls. Specialized barns were created for all sorts of needs. Tiny barns built over free-flowing springs became Spring Houses; other barns became Milk Houses, Cider Houses, Pig Houses, Butchering Sheds, and Smoke Houses.

Barn-raisings were community affairs in which neighbors assembled with long pikes, axes, and mallets to shape raw oak lumber into huge beams which were held together by mortise and tenon. The resulting frames were eased upward with long pikes, and then rafters were pinned to the resulting structure, making the skeleton of a barn. Oak flooring was laid, and the outer sheath (also made of oak in the form of vertically-oriented rough-sawed planks) was attached with wrought nails, and later with square-headed cut nails. This wooden barn was clearly the center of a way of life and work; its passing marked the end of human and animal power and the supremacy of the internal combustion engine.

Cows and horses suddenly became superfluous, but the barns remained standing long after the animals that once sought shelter in their cavernous interiors. Built like cabinetry, they proudly resisted the prevailing westerly winds that each year removed a cedar shingle or loosened a hinge or pulled out a rafter pin. Long after Old Dobbin had gone to the glue factory, his stall remained inside an old barn now weathered and gray. Yet it wasn't the weather, with its alternately tropic and arctic ferocity, that ultimately destroyed the barns. Maintenance and upkeep simply became too expensive; oak lumber was hard to obtain—and more costly. Tax assessors docked the poor farmer heavily for keeping that large, improved outbuilding on his land. In the end, it often seemed easier and cheaper to summon the bulldozers and demolish the barn. The once-proud building was reduced to an undignified heap of splintered lumber.

Farm children once played cops and robbers in these buildings. Jumping from the hayloft into the grain bin became a parachute game, and rural romances often began with a proverbial "roll in the hay." For a few decades, the barn co-existed rather congenially with the Tin Lizzies, and many a car collector has discovered some automotive treasure nestled under a mound of straw. Stirred by nostalgia or cussedness or whatever, some farmers decided to keep their barns properly maintained. Most, however, replaced their barns with metallic machine sheds, mass-produced, quickly assembled structures that were aggressively peddled by salesmen in houndstooth jackets who made a quick profit and left an eyesore on the landscape. The smell of the old barns—a complex mixture of dust, old wood, birds' nests, straw, animal sweat, and manure—was replaced by the acrid scent of metal and exhaust fumes. It was about this time that chickens disappeared from farm yards, and farm families tooled into town to purchase the milk and cream they once produced in their own back yard.

So the passing of barns is really the passing of an era, one more example of the technological revolution that has been going on for some 200 years. But in the last decade or so, a counter-revolution has occurred, a change in sensibility that causes us to value hand-crafted and well-made objects—and to restore or recycle them whenever possible.

I visited the Albert Schnepp barn, which stands on about 500 acres of farm land about one mile from the Sangamon River in rural Cisco, Illinois. Built in 1916, the barn has become a five-year project resulting in a lovely three-story home with two huge fireplaces, two levels of docking, and 4,600 square feet of living space. By using all the original beams and kickboards, the Schnepps created a lovely interior space which is warm and snug, in spite of its vastness.

No one has taken a census of recycled barns, but there are several dozen (at least) between Champaign, say, and Peoria. A small company in Peoria (The Barn Doctor) actually restores and recycles barns into handsome dwellings, working with the original structure and the ideas of adaptation provided by the owner. The adaptive re-use of barns is one of the most architecturally exciting trends in Illinois today, combining our general love of antiques with a desire for personal expression through architecture. In a way that no one expected, the old Prairie Barn is proving to be a tough survivor.

When I moved to central Illinois, I had completely forgotten my earlier love of barns, acquired in childhood visits to my grandfather in the Deep South. A cotton farmer, he often packed his barn with billows of cotton, especially in the good years when there was enough of the white stuff to flood the market. On one visit I climbed to the uppermost rafters and let myself drop down into that wonderful whiteness, time and time again. It was as if I were dropping into the clouds and being sustained by some kind of magic. I'm sure it's the closest I'll ever get to heaven itself.

Shadows

It had been the worst winter in one hundred years. Over eighty inches of snow had accumulated over the surface of the great city, turning the neatly cross-hatched streets and intersections into a smokey, glacial mass from which the glass and concrete towers protruded eerily. We thought the winter would never end, so when the sun signs shifted and the long golden evenings signalled the approach of springtime, a general laziness fell over the population. The big tavern threw back its doors, golden liquor flowed, and all drinks were on the house. I pointed my pickup truck due south, leaving behind my high-rise apartment on Lake Shore Drive, overload springs sagging under a heavy load of books and furniture, bound for an uninhabitable farm house I had just purchased on the edge of Shelby County.

From the spattered windows of my pickup truck, the world became a diorama of thawed fields, swollen creeks, and abandoned barns. The silhouette of the old Chevy sliced through the brilliance, trailing a lonely, blue-gray shadow over fields and hedgerows. Slowly we were moving south, one rectangular field at a time, part of the calculus of time and space, a movement so subtle it could only be measured in the progressively darker tones of trees and shrubs. Something like green smoke was gathering in the white branches of sycamores and the whip-like extensions of willows and soft maples. As the sun sank lower and lower, the truck's shadow loomed larger and larger, like a Gila monster grotesquely expanded, slithering on its belly in absolute speed and silence. It swallowed every fence post and field row, claiming everything as part of itself, moving without the slightest bump or hitch. My little daughter, who was born at the outset of that terrible winter, pulled herself up by the collar of my parka to share in the hypnosis of the afternoon. It's hard to pinpoint that joy, partly nostalgic, partly childlike, but we shared it until the last ribbon of sunset faded somewhere over Iowa and the blue lights of farm houses began to pop on and twinkle at the edge of the prairie. Only something as big as the night could swallow Illinois.

A House in the Country

In 1908, the year Henry Ford introduced his fabled Model T to the American public, three carpenters whose names I'll never know arrived at the spot where my house now stands. Using only simple hand tools and wagon loads of oak, pine, and cedar, they built the house in which I live today. In the process of restoring the old structure, I've torn apart seams, joints, and joists placed there by these anonymous builders.

In overall shape, the house is cruciform, and three porches nestle comfortably in the arms of the cross. Its common box frame is like those that supported the walls of frontier and prairie houses from western Pennsylvania to Nebraska. The floors, of narrow oak boards, responded well to the impromptu buffing provided by my crawling daughter as she dragged herself from room to room. Plumbing, wiring, outlets, and light fixtures were modern amenities added in the twenties. As far as I can tell, we are the fourth family to live in the place; it has a history of its own. I will often meet someone here in rural Shelby County who will say something like, "Oh, yes, that's a good old house. I remember playing bridge there in 1927."

It isn't every day that history is placed in your hands in such a tangible way. I performed my best detective work, but I turned up few clues. The downstairs and upstairs yielded precisely two items: a moth-eaten pea coat and an old wooden cheese box. Under the back porch, I found two old medicine bottles and one old-fashioned whiskey flask, the kind that was stoppered with a cork. Clearly, these vessels were relics of good and bad days long past, but surely there must be more. Someone planted these lilac bushes, one for each point of the compass. One peach tree had survived the terrible winter, and the two huge maples must have been here before the house itself. A ghostly depression in the corner of the back yard suggested a garden long since gone to seed. But I craved some intimate and revealing artifact that would illustrate the day to day quality of the lives lived here for some seventy years. Clearly, this yearning wasn't part of the

real estate transaction. Maybe I wasn't a historical detective but merely a frustrated voyeur.

It was during this time that visitors began dropping in, usually to check me out, assess the quality of my carpentry, loan me tools, trade garden produce (my zucchini for your broccoli), even to offer me the odd-sized windows and doors I needed to put this 1908 model back into operating condition. At some point during the visit, they inevitably referred to The Door. Sometimes the comment came offhandedly, as in, "Real shame about the door. It was a collector's item, you know."

After a few weeks I began to take mental notes, strike out discrepancies, and reconstruct their piecemeal commentary into a single coherent story. It appeared that for most of its life, the house had boasted an ornate, oaken front door, the upper half of which consisted of a well-framed frosted glass pane on which a woodland scene was etched. Here the stories diverge, but all agreed on a few basic points, namely, that the scene depicted a tender family moment in the life of deer, a buck, doe and fawns in the forest. At least one "witness" insisted that there were exactly five deer and that they were drinking from a woodland pool.

For weeks I was alternately haunted and tormented by images of that door and those five deer drinking. One spring evening after my fingers were swollen from too much hammering and my back twitched from the unaccustomed load of two-by-fours on my shoulders, I left the house for a drive, deliberately choosing the deep-rutted, unidentified roads that follow Lake Shelbyville. We were bumping along through the trees when my wife began shouting frantically, and I pushed down hard on the brakes. There in the yellow beams of the old truck's headlamps stood a group of deer drinking from a pool of meltwater. They looked up once, and then went about their business as if the noisy valves of the truck's engine weren't disturbing their peace at all. I was too dumbfounded to turn off the motor, but eventually I began to count...one, two, three, four, five. Three fawns, a buck, and a doe. Then they disappeared in a blur that faded into the gathering darkness on either side of the road. Somewhere in the back of my mind, I heard the distinct sound of something slamming shut, and in the only way that would ever count, I knew I had found that door.

Lake Shelbyville in Winter

One of my neighbors likes to tell the story of how her grandson walked across Lake Shelbyville by stretching an old barn plank over the water and simply pacing the short distance from shore to shore. There's a bit of wry rural humor in that story because when it happened (in the early 60s) there was no Lake Shelbyville, only the confluence of the lazy West Okaw and Kaskaskia Rivers. Fields and farmhouses overlooked a sleepy river valley where deer came down to drink and the old catfish did their predictable belly-flops in mid-summer. Over 5,000 years ago, Indians began to build semi-permanent settlements in the same valley, and, according to Tom Riley, Professor of Archaeology at the University of Illinois, there once were some thirty sites scattered along the river banks, representing successive settlements by Archaic, Mississippian, and Woodland Indians. These local Indians were poor relations of the more famous Indians who built the huge Monk's Mound at Cahokia, but they are worth recalling because Lake Shelbyville is a strangely moving place, full of old dreams and buried memories. Begun in 1963 and finished in 1970 at a cost of 56 million dollars, Lake Shelbyville (according to the Army Corps of Engineers) is a place of the present visited by three million people annually. It is also a place of the past where one might uncover a spear point, pottery shard, or even a delicate fossil. My little daughter found a fossil of a vine that probably grew just after the last glacier withdrew and scraped out the shape of the land as we know it today.

I mention these successive settlers and the contours of the earth because the construction of the present dam meant a good deal of uprooting and disruption that left a permanent bitterness in some of the local residents. One family used to have a lovely farmhouse atop the bluff which now forms the circle drive at the very tip of Eagle Creek State Park. Personally, I've found few Indian relics, but many times while hiking along the shores of Lake Shelbyville I'll stumble upon the remains of a house or farm. Ghostly outlines of farmhouses persist as a pattern in the weeds. A stray piece of barbed wire is still looped around a giant shagbark hickory.

In the middle of second-growth forest I've encountered grape arbors, day lilies, and blossoming yuccas—all planted by phantom tenants who have long since disappeared. In order to dam up (or "impound") the waters of the Okaw and Kaskaskia Rivers, the U.S. Army Corps of Engineers tore up roads, moved tombstones and fences, built a 110-foot-high dam at Shelbyville, and erected a 3,200-foot-long bridge at Findlay. Old-timers still recall the pie-in-the-sky sales pitch that went with those massive rearrangements and relocations. The new lake, it was promised, would provide an economic catalyst for the area by creating a resort area with bait shops, recreation and sporting goods stores, and restaurants. Somehow these places never materialized, at least not on the scale that had been promised. Visitors tended to come with their own food and supplies, seeing Lake Shelbyville for the bargain that it was. The other promise concerned flood control, but if you ask people south of the dam, especially around Ramsey, about flood control, they'll probably quip that what they have now isn't flood control but controlled flooding! Marginal and bottom land may still come under a few feet of green water that drowns or rots even the hardiest varieties of corn and beans. I can't look at the lake without somehow acknowledging these genuine setbacks, but I know I love the place, and, like thousands of other visitors, I'm grateful for its mirror-like presence. Five years ago I moved close to the lake, and I have walked its shores three or four times a week, even during the worst of winters.

It would take the subtle skills of a watercolorist or nature photographer to make a decent representation of Lake Shelbyville. It's hard to capture those shifting tones and textures; a surface that is alternately placid as moonlight or boiling like a tornado—a medium that is tinged with the deep green of the shoreline, the romantic blueness of the sky, and the nameless shadings in between, the unsung colors of aluminum, violet, and Coke-bottle green. Even winter's ice cover is never uniformly white but pearl gray in the daytime, lavender in the evening, and indigo on those fault lines that signal the coming of spring.

"Lake Shelbyville" is really an umbrella term for a collection of waterways and recreational areas, marinas, scores of shelters, outhouses, picnic tables, boat ramps, camping setups, and two beaches. There are fish hatcheries and stocking facilities at the West Okaw River Fish and Wildlife Management Area (near Sullivan) and ecological and environmental study areas near Kirksville and Bruce. The Corps of Engineers maintains the dam and a year-round Visitor Center and also provides a number of interpretive programs with such titles as "Secrets of the Plant World," "Slitherin' Snakes," and "Native American House-building." The Illinois Department of Conservation oversees animal protection and maintains

the trails and nature feeding sites. All in all, about fifty people are working on or around Lake Shelbyville at any given time.

If you saw Lake Shelbyville from the air—or perhaps from a satellite—it would resemble a large "Y" made up of thousands of intestinal bends and hooks. All sorts of creeks (Wilborn, Eagle, Opossum, and Wolf) feed into the main channel. Giant fingers of heavily timbered land probe into the water from all directions, creating natural coves and backwaters for the various fish that populate the waters. The trees are mainly hickory and oak, with a fair sprinkling of sycamore, maple, and dogwood. All the common wildflowers and weeds occur naturally, including spiderwort and rattlesnake fern. A few restored prairie sites boast stands of billowing bluestem. Many people come to the lake to enjoy these simple pleasures, or to hunt and fish as the first (Indian) residents did. Of course, the Indians didn't cruise the waters in ten-thousand dollar bass boats or shoot deer with high-powered bows. Every fall I see the hunters arriving in camouflage clothing and day-glo hunting vests. I know the white tail deer populations need to be thinned out, but I do hope these shots are clean and sportsman-like. The thought of a doe or buck limping along the trail with an arrow in its haunch or belly causes me sharp pain, too.

Deer are my most frequent companions when I walk the lake. They are surprising creatures in many ways. Delicate as ballerinas, they can nibble at seed pods and leaves as if following some secret book of etiquette. Their startled leaps, four or five feet into the air without a running start, could make Baryshnikov or Nureyev weep. But deer have an ugliness that is equally remarkable. The animal seems to be the product of a committee; it sports camel ears, sagging donkey belly, and a funky little tail that pops up like the marker on a rural mail box. Last winter I was hiking along the trails of Eagle Creek with my best L. L. Bean outfit (ragg socks, two lumberjack shirts, heavy parka, and aviator glasses), following deer tracks frozen into the hard snow at the side of the road. The wind chill was close to zero—or below. I was squinting at an unaccustomed sight of bushes that stood at a familiar bend in the road. An old blue Chevy station wagon appeared at my side, moaning in first gear. Grandma and Grandpa were out cruising, heading toward those strange bushes I had never noticed before. The car rumbled on for about another hundred yards when the bushes began to explode, flying apart like petals on a flower, and four deer sailed magically over the hood of the Chevy.

I've witnessed (and I use this term in its religious sense, too) many waterfowl and field birds around the same spot, especially meadowlarks, indigo buntings, catbirds, orioles, red-tailed hawks, scarlet tanagers, and, once, five jumpy little eastern bluebirds. Mallards love to nest in the coves, and, rarely, I see wood ducks and Canadian geese. The Visitor Center displays bufflehead and green-winged teal—maybe I'll spot them on some

lucky day in the future. I have come upon a mother coyote and her pups, emerging from a little cave at the mouth of a tiny, unnamed creek. Once I saw a small red "dog" that proved to be a fox. Those swift little dogs keep popping up, especially in the side mirrors of my old pickup truck. I don't count the box turtles and cottontail rabbits; they just seem to be a part of the ambience of the place, like lemon-yellow leaves in the early fall and luminous fireflies in the spring.

Memories and images aren't the only things that people take away from Lake Shelbyville. It's a warm and reassuring feeling to pull your boat from the water at sundown, knowing it contains a cooler filled with crappie, walleye, or trout. Catfish lovers string trotlines in the moonlight and arrive at dawn to harvest their spiny catch. There's a lot to enjoy here, with 11,000 acres of available water and over fifty miles of trails and roads. My best moment at Lake Shelbyville occurred last winter when an immense barred owl took off from a hickory branch directly overhead. That huge bird, as big as a turkey and covered with gray and black convict stripes, seemed to symbolize all the beauty and mystery of the place, that nameless something I kept coming back to find. As I was driving home across the Findlay Bridge, over the ice-packed lake, I looked up to a pale winter sun encircled by "sun dogs" (glowing rings around the sun), and I heard that small, trustworthy voice whisper, "Now—enjoy it now."

The Plain People:
A Portrait of the Illinois Amish

Driving east of Lovington on Illinois 133, I found myself slipping into a genuine time-warp. Motorized traffic became thinner and thinner as the fields grew progressively smaller. Neat squares of oats and clover alternated with fields of corn and beans. Horses were everywhere. I mentally downshifted from the high speed of the automobile to the clippety-clop of the horse-drawn buggy, that black boxy vehicle that has become a virtual trademark of Amish culture. I was in the middle of the Illinois Amish settlement, an area of about one hundred and twenty-five square miles bounded roughly by the communities of Arthur, Bourbon, Chesterville, Arcola, and Cadwell, lying at a spot on the Illinois map where Douglas, Coles, and Moultrie Counties lock together like parts of a giant jigsaw puzzle. It was "dinner-time" (noon) on a high, blue day in early summer. Farmers dressed in homemade coats and "barn door" pants with button-flap fronts were returning from the newly-planted fields, joining their wives and daughters who were dressed in homemade solid-color dresses of lavender, blue, or black. Every woman or girl protected her head with a delicate organdy *Kapp*, a kind of fine mesh bonnet perfectly suited for warm work in kitchens or milking barns.

The men all sported flat black hats or old-fashioned farmers' straw hats, and each one had his hair cut in a bowl-shaped style reminiscent of the Beatles or the Three Stooges. Spade-shaped beards were common, but not a single man grew a mustache. After reading Clyde Browning's privately printed book, *Amish in Illinois* (1971), I learned that the mustache symbolized Prussian militarism and, hence, was strictly taboo. The clothing, I discovered, followed patterns that were popular in sixteenth-century Switzerland and Germany. Browning's book satisfied other points of my curiosity, filling me in on the history of these simple, hard-working folk, still considered to be the purest Amish community in the United States, and possibly the whole world.

The Amish have always been persecuted, for theirs is a tradition of non-violence and separatism: they have lived apart from non-Amish society and strongly condemned its worst aspects (particularly greed and violence). As stubborn pacifists, the Amish have been jailed, beaten, and tortured for hundreds of years. As recently as our own second World War and the Vietnam War, Amish men were abused while serving in non-combatant roles (hospital orderlies and the like), and several older Amish told me of frequent incidents of verbal abuse during the Vietnam War. An Amish man could not buy a cup of coffee or a sack of flour, it seems, without enduring some ugly slur. Sometimes the abuse took a more physical form as many an Amish family found a rock or brick thrown through the window of their buggy as they drove along the normally peaceful lanes and back roads.

None of this intolerance would have surprised Menno Simon, from whom the Mennonites take their name. He broke with Luther around 1536, stressing a creed of non-violence, separatism, and adult baptism. In 1693 one of his followers Jacob Amman, formed a splinter group who became known as the Amish. This splintering, a typical development in Protestant sects generally, has produced a number of curious variations in and around Arthur, Illinois where the Amish settled in 1865. I saw Amish folk plowing their fields with teams of horses, while a neighboring Mennonite drove by in a pick-up truck. There was a perplexing mixture of Mennonites, Old Order Amish (the purest of the pure), and New Amish (who used some—but not all—the modern conveniences). Technology and theology were curiously intertwined: what you believed determined what kind of widgets you could own. Marx Miller, the genial Amish owner of The Old Store in Cadwell, explained to me that the issue wasn't electricity or television or automobiles as such but rather what these things *led* to. "You just can't own those things and be Amish," he explained quietly. And that remark triggered the real question that had brought me to this lovely and peaceful corner of Illinois. I wanted something more than the tourist's shallow appreciation of the "cute" buggies and the "quaint" people in beards and bonnets. What *did* it mean to be Amish?

Outsiders tend to answer this question with a whole series of negatives: *no* tractors, *no* cars, *no* electricity, *no* buttons (some Amish are called "hook and eye" Amish), *no* war, *no* divorce, and *no* photographs. I stood outside The Old Store on an utterly beautiful afternoon, watching the red wing blackbirds taking off and landing on the fence posts, when for no apparent reason an old bell began to ring in the distance, and I was surprised by a deep sense of happiness welling up within me, the result of a week with the Plain People. What did a *lifetime* in this place produce, besides the homemade butter, jams, buggy wheels, horseshoes, bread, rocking chairs, sausage, cheese, and other products being sold at nearly

every farm? This life of the Old Order Amish yielded simplicity, a pure manner of living and working that had been commonplace a hundred years ago. As I listened to the soothing music of the old bell, I reflected on electricity and television: in the past few days I had seen Tina Turner grunting and gyrating on the tube. I had seen news reports of terrorist bombings in Tripoli and the agony of hostages on a hijacked plane in Beirut. Another story had provided the graphic details of a seven-year-old Illinois girl and her grisly abduction and murder. I thought of my own daughter, and I was overcome with a profound feeling of shame and disgust at the sleaziness all around us. It was impossible to do a story on the Amish without simultaneously doing one on myself. Every paradox and oddity of the Amish somehow reflected on me and my people—the "English" as Marx Miller called them.

How *did* the Amish cope with these ubiquitous evils of modern life, I wondered. "We're not better than other people," Marx Miller insisted, "just different." Yes, there were instances of social problems, including promiscuity and drug abuse, even among the Plain People. And weaker members of the Amish Church suffered *Meidung*, or "shunning," a kind of temporary excommunication—which could be (and has been) applied even to the ministers. I assumed a kind of Salem Witch Trial atmosphere colored this whole procedure, but Marx assured me that the whole process was one of healing, not hurting. Those who had strayed from pure Amish belief were constantly encouraged by the rest of the community to make a public confession and re-join the fold in a ceremony that amounted to a second baptism. I began to sense a warm humanity in these people; they were not just a band of hard-nosed zealots. They were human beings who cared intensely for one another. When tornadoes recently struck an Amish community in Pennsylvania, neighbors helped one another erect new barns and buildings immediately. The Amish delight in helping one another; a genuine ethos of community service pervades every Amish settlement.

There was joy in this Old Order. Marx gave me a tour of his house, which was so clean that even the baseboards gleamed. Like all Amish, he was proud of his hand-crafted oak furniture, his indoor plumbing (fed with water from a cistern), and his bountiful gardens. The large raspberry patch was especially inviting. Here, and at every Amish home I visited, small flower beds caught the eye. Flowers were placed strategically next to buildings or on the borders of the vegetable gardens—food for the eye and the body. Plain did not mean ugly, I was learning; again and again I was struck by the aesthetic of plainness brought to the level of art in flower arrangements, pie-making, furniture, and, especially, quilts.

Admittedly I had come to study and observe the Amish, but I soon found myself liking them, enjoying my time with them more and more,

noticing how many strangers waved to me from their buggies. I had been warned to expect suspicion and a general lack of cooperation; instead, I found myself engaged in two- or three-hour long conversations. The pace of life was different. Anything worth doing was worth doing well. The Amish are one of the last small-scale communities in the United States. Their world is bounded and defined by the distance a horse could travel comfortably. They live by their wits, and they waste nothing. How fragile their world seems in the midst of rising divorce rates, "latchkey" children, microwaves, computers, and fast food. The Amish live at the edge of an uncomprehending and overwhelming culture that offers a dizzying array of temptations and distractions. Like other distinct cultural groups (Orthodox Jews, French-speaking Cajuns, American Indians), the Amish are struggling to preserve their identity and their future, and that struggle focuses on land and children. Two recurrent themes in many conversations were the economic impossibility of farming and the refusal of some Amish children to join the Church. The Amish have large families, but they don't seek converts. So every Amish child who refuses baptism at age eighteen is an expensive loss for this close-knit society. And if regular farmers have a hard time making profits in a world of John Deere tractors, hybrid seeds, pesticides, and fertilizers, imagine the plight of the Amish farmer with, say, eighty acres and a team of horses!

Amish farmers tend to have such small plots because, typically, a family's land has been divided over and over to give each generation a field of their own. That process can go only so far, given the large size of the families and the limited availability of land in the area. That is why so many of the Amish have turned to other, non-agricultural jobs, like cabinet-making, woodworking, and the like. But many farms *do* exist, and the typical Amish farm is centered on the barn, an Amish family's proudest possession. "The barn makes the house," Marx Miller observed, repeating an old Amish saying. Two generations usually live on the farm, the son in the large house and the father in the "grossdaudy" or grandfather's house. The main house will usually have water provided by a cistern or well, no electrical outlets, and movable walls so that the services (held every other Sunday) can occur right in the home. The Old Order Amish erect no church buildings. The church *is* the home. Work, religion, and family life are a continuous circle of activity beginning and ending on the farm. There are usually horses, pigs, chickens, vegetable gardens, and flower patches everywhere. There may well be a stationary diesel generator in the barn, providing power for pumps or other farm machinery. It may seem illogical to the outsider, but while the generator is allowed, tractors and television clearly aren't. "You just can't own those things and be Amish." The horses are bought, sold, and traded at the Arthur Sale Barn at regularly held auctions. The finer horses, often of thoroughbred stock,

are kept for light buggy work; the heavier draft animals are used to plow the fields. Nearby shops keep the Amish horse and buggy in good running order: there are shops for buggy and harness repair as well as blacksmith shops, like Reuben Schrock's Blacksmith Shop south of Rockome Gardens.

The artistry of Amish farm life is best expressed in cooking and quilting, crafts every Amish woman is expected to master. I visited Edna Miller, who operates Miller's Home Cooking on Illinois 133, just west of Arthur. She cooks by reservation only, there must be a least ten in the party before she'll fire up the stove, and she has no phone. But these inconveniences are well worth enduring when one considers the lavishness and quality of the meal, all prepared by hand. Amish cooking is not for the Perrier and salad-bar crowd. The food is substantial and filling, reflecting its German origins, and meeting the needs of hungry farm folk who require substantial meals. When I visited Edna, she was preparing the chicken stock that forms the basis of her famous chicken dressing. Although she could easily tell me what the ingredients of this—and other—dishes were, she couldn't specify exact proportions or measurements. She doesn't *use* recipes, because every meal is prepared by instinct and memory. The dishes she serves are the same ones served by her mother, grandmother, and great-grandmother before her.

Edna Miller has operated her restaurant since 1972 in a large dining room added to the side of her typically Amish house. She is open from March through December, every day of the week except Sunday. The largest group she cooked for numbered over one hundred; the smallest was ten. Family reunions or church-related groups often reserve places, but tourists from Chicago and St. Louis usually drop by—as well as exotic visitors from places like China and Japan. Once she cooked for a group of forty, and no one showed up. In typical Amish fashion, she simply shared all the food with her neighbors so that not a single morsel was wasted. While we were chatting, Edna gave me a tour of her immense and spotless kitchen, her six stoves, and two long tables where freshly-made noodles were drying. The noodles are offered for sale, as are the angel food cakes she regularly bakes.

I returned later to sample the food, which her daughters served family-style in large plain bowls. A horse and buggy were tied to the hitching post just outside the window, and I gazed at the horses, the barns, and the fields of grain during our long, lazy meal. Amish children played tag in the yard. Family members ate in the kitchen while the paying guests filled their plates in the dining room. No one was in a hurry. We ate off simple plastic dishes, drank from plastic tumblers, and sat on the same hard benches used in the Amish services. The table was set and furnished with freshly baked bread, homemade butter, and homemade strawberry

jam. I wish I hadn't "sampled" these items so diligently because I failed to leave adequate room for the avalanche of food that followed: baked ham, fried chicken, mashed potatoes (real potatoes, of course), brown gravy, green peas in a delicate cream sauce, chicken dressing, lettuce salad with a sweet and sour dressing (of Dutch ancestry, no doubt), freshly brewed coffee and iced tea. Each dish was succulent and delicious, but I award the blue ribbon to the chicken dressing, a quiche-like dish of egg, chicken, broth, celery, and a generous portion of Amish magic. Edna is justly famous for her pies, and she always serves a "hard" (apple, cherry, apricot) and "soft" (custard, chocolate, peanut butter, coconut) variety. That night we had the custard and a raspberry cream that should be outlawed because absolutely no weight-watcher can ignore this tempting confection of fresh raspberries, sweet cream, and flaky crust. The tab for this feast was exactly $7.00 per person, including seconds on the chicken dressing, potatoes, peas, and coffee.

There are many other gourmet delights to be had in Amish Country. Das Schlacht Haus (The Slaughter House) offers superb cuts of locally-grown beef and pork. Their price lists includes over fifty meat items, including German bologna, filet mignon, butterfly pork chops, bratwurst, and pork or beef headcheese. Some customers buy whole sides of beef or pork, but most drive down to buy a few pounds of pork chops or a freshly cut porterhouse. On the north side of Arthur stands the Arthur Cheese Company, which offers over twenty-five different kinds of cheese, including speciality items like low-fat Swiss cheese and port wine cheese spread. About two miles east of the Arthur Cheese Company lies Annie's Bakery, well worth visiting for the pumpkin bread and the luscious "Texas" brownies, a combination of marshmallow, chocolate, and cake brownies. I had to ration my supply after my daughter's friends attacked my bag of samples. The Old Store in Cadwell offers homemade soap, Amish cook books, homemade apple butter, and locally grown popcorn.

Amish craftsmanship extends to more than cooking or foodstuffs. Everyone in the area seems to be an expert at something produced lovingly by hand. Museum-quality oak furniture is featured at F. and B. Woodworking (east of Cadwell); I especially liked a glass-fronted, sectioned bookcase made of solid oak. Oak rockers, chairs, tables, and hutches were on display on two separate floors. I spent a rainy afternoon chatting with John Marner, a Mennonite, at Marner's Lamp Shop in Chesterville. The lamp business has declined sharply since the early 80's, a sad victim of Reaganomics, according to John. He still sells lamps, but now he also uses his truck to "import" reasonably-priced oak furniture from Amish craftsmen in other states, especially Ohio. He had a lovely set of oak lawn chairs on display. John took me to his workshop in the back of the store where stacks of rough-sawn cherry planks reached all the way

to the ceiling. We left our tracks in the sawdust-covered floor. John showed me a grandfather clock he was finishing. The rest of the shop was filled with partially finished china cabinets (the kind with curved glass fronts) which John and his family make in the shop and sell at highly competitive prices. His eyes actually lit up when he described a well-made piece of furniture.

My single favorite among all the items I saw during my week in Amish country was a blue "starburst" quilt which Edna Miller had almost finished the first day I visited her. The starburst pattern is a classic one, as quilt collectors will recognize, consisting of a geometric six-pointed star in the center of the quilt, enhanced by geometric "rays" extending to all corners of the quilt. This particular starburst was done in three or four tones of pastel blue. The overall effect was stunning. I kept thinking of the Oriental artistic principle that "Less is more." The plain people were not so plain, after all. Edna showed me sections of a new quilt, a "flower basket" design with an embroidered basket in the center and various geometric flowers on each side. I thought of it as another neat little flower patch, like the ones I had been enjoying at every farm I visited.

Many times I would be taken aback by a strange mixture of the old and the new while visiting these gentle people. I remember an Amish or Mennonite man in frock coat and straw hat pushing a Lawn Boy lawn mower. I witnessed an Amish teenage boy in homemade clothes, pedalling an old-fashioned, balloon-tired bicycle on a nameless back road through the cornfields. I watched Amish boys playing a spirited game of baseball in a big meadow, with only horses and cows as spectators. I listened to an Amish matron speaking in the Amish dialect, a kind of sing-song German to a patient young shopkeeper, who nodded his head repeatedly and uttered a single syllable: "Ja." I became accustomed to the horses and the beautiful trotting motions they made across the line of sight—I even grew used to the horse droppings which littered the areas around hitching posts and the access roads to farms and businesses. Every form of horsepower creates some kind of pollution.

One part of me admired the Plain People and wished them every success, but another part feared that this little utopia could not survive. Some of the farms were becoming shabby; many houses and barns were in sore need of a good coat of paint. It seemed harder and harder to keep the young men around. Non-Amish residents took great pleasure in telling me tales of Amish teenagers who stashed their jeans in the back of the buggy and went out for a night on the town. Other people complained that the buggies were always in the way or that the Amish drivers didn't pull off the road soon—or often—enough. There may have been some truth in those claims, but the bitter tone in which they were voiced left me rather uncomfortable. Had we become so arrogant in these last decades of the

twentieth century that we could make no room for these people? Did everyone have to belong to the Pepsi generation? I hoped not. I remembered an anonymous little poem I found in Paul Miller's book, *The Illinois Amish* (Peqeau Publishers, Gordonville, PA, 1980). Entitled "People" the poem completely captures that special Amish belief in plainness and emphasizes the absence of pride or pretension:

> We all have plenty of shortcomings,
> My experience tells me this is true.
> For me, I'll take the common people
> And let the proud ones go for you.

At some point I began to fantasize about being Amish. I'd picture myself in a black hat and beard, using some typical Amish surname like Yoder, Miller, or Schrock. I'd walk through the oat fields in the evening with my frock coat flapping in the breeze. Perhaps I'd be walking toward a beautifully painted red barn where my "courting" buggy waited with my best horse. Maybe I was going to meet some lovely red-cheeked girl, her blond hair covered by a dainty *Kapp.* Then I'd stop and realize how silly all this speculation was—how un-Amish! Being Amish wasn't expressed in styles of dress or even styles of courting. It was a deep feeling of cheerfulness, an abiding sense of the goodness of life. There was a beautiful moment each day in Amish country when the sun went down, the chores were done, and all the courting buggies came out. Evening is the traditional time for courting, and everyone I'd meet would be smiling and cheerful. The back roads filled up with buggies, and everything moved along gently. A violet glow gathered over the fields, broken every now and then by the silhouettes of horses and buggies. I was sure I could hear that old bell ringing again, somewhere in the distance.

Saws, Boats, and Photographs

Entering the turn-of-the-century shop in downtown Shelbyville, I instantly appreciated the glass and walnut counters, the high ceilings, the antique clock, and the old guns mounted on the walls. That hand-lettered sign in the window promised Saws For Sale, and, indeed there were some chain saws scattered about, most of them in various states of disrepair on the worn surface of an immense work table. At a glance, however, it was hard to tell exactly what was being bought or sold on these premises. The glass counter top was littered with stacks of homemade photo albums, stitched together on the heavy-duty sewing machine parked in the back corner.

The photographs were small black and white Polaroids. Bob Klauser hovered around them like a hen protecting the chicks. Each photograph, he explained with a chuckle, celebrated the sale of a chain saw. Most pictures were snapped right in front of the old shop, in all kinds of weather. The finned automobiles and venerable farm trucks were tangible proof of the mysterious passage of time that had occurred since the date of purchase. On the white borders Bob Klauser had pressed in the date with a ball point pen, thereby rescuing an ordinary event from the anonymity of time. A little gallery of human relations and memories was contained in these small square images, stitched into sheets of clear plastic and lovingly displayed to all visitors and potential customers. A patient tally revealed over 1,700 photos on the counter top, a figure that represented about half of all the saws Bob Klauser had ever sold. Three generations of customers appeared in these pictures, Bob explained, and his speech became lazy and more rural-sounding as he drawled into his stories. "I've sold them to the third generation time after time. I've sold the grandad, then his son, and then HIS son."

These snapshots would delight an urban archaeologist, one of those specialists who document the clothes and customs of everyday American life. One man held his chain saw like a weapon, hoisting it high over his head. One wag pretended to saw off the top of a parking meter. Another

21

fellow brandished two saws simultaneously. Family shots abounded: mother-son, father-son, husband-wife, father-son-grandson. "People see their aunts or uncles in these photos. I recapture the moment...I see some guy there who was my friend. The older I get, the more I'm gonna treasure these pictures, I'm sure."

As we leafed through the sheets of photographs, Klauser would pause and savor some salient memory. That customer, for example, had two artificial legs. This man had bought three saws at one time! That guy had a pacemaker. Here was a former classmate. And this lady had saved the egg money to surprise her farmer husband with his first power saw. Here was the couple whom Klauser had entertained with Polish jokes. "They weren't bad Polish jokes," he insisted. But ultimately the joke was on him, for the couple (campers from Chicago) were, in fact, Polish. Humor saved the day, however, as the couple became owners of a fine new saw and Klauser added another photograph and story to his growing collection.

My favorite photo-story combination involved a rural rake who appeared in high spirits one Christmas eve, flashing a fistful of hundred-dollar bills. "It occurred to me," said Klauser, "that I could help him part company with those bills." The photo shows him at the giant work table, still clutching the bills before surrendering them for the massive saw lying on the table top. It turns out that he was something of a legendary figure in the annals of rural Shelby County and that, even though his son and brother appear in other Klauser documentary shots, the real story cen-tered on the feud that erupted between him and his brother, cause unknown. They had "agreed to disagree," and their resultant feud lasted over a decade, assuming a kind of romantic coloration as if it were on the same scale as the great feud of the Hatfields and McCoys. Klauser would receive updates and anecdotes as new customers surveyed the aging photographs of the two brothers. In a strange way that no one completely recognized, the photographs became part of the saga, artifacts of happier days when the two brothers were still on speaking terms. Family unity counts heavily in the country, and it gave Bob Klauser considerable pleasure to announce that the brothers had been reunited only weeks before our first interview. The lines between friends and customers, between the world of hard sales and that of human feelings had become blurred in altogether interesting ways.

This collection of photographs had evolved naturally and acciden-tally, the result of a promotional campaign started by Homelite Chain Saws. Bob Klauser had acquired the local franchise for the hot-selling Homelite XL-12, and he exercised an option to buy Polaroid Swinger Cameras (then novelties) at cost—in the hope of making a double sale. Klauser bought two cases of the cameras, but "customers didn't come here with cameras on their minds, so I started taking a picture with each saw I

sold. I started thinking of it as a sales tool. It kind of happened by accident. It just fell into place."

The photographs of the chain saw customers led us to other photographs scattered around the shop. There was a tintype of Klauser's grandfather (dated 1875), who had left Germany to avoid military conscription. He had begun the Klauser family business in 1882, repairing harnesses, bridles, and reins in the golden days of horse-drawn implements. His brother took over in the early 1920s, and Ned Klauser, Bob's father, bought the business in 1929, probably the worst year in American history to embark upon a business venture. Ned survived, in spite of the Great Depression, by dint of hard work and creativity. Ned branched out into new areas, like the manufacturing of combine canvases. Bob took over the business in 1955, and everything changed drastically. But I'm getting ahead of the story because Bob figured in the business long before 1955, as a 1933 photograph suggests. Bob is a cocky kid, standing in a pile of bridle leather. His dad leans on the counter, wearing his visor and work apron, surrounded by horse collars and tools of the trade. In the back of the store stands a wood-burning stove with crooked flue and, of course, the same antique clock I noticed on my first visit. After the long Depression, Bob enlisted in the Army, and more photographs came into his life.

Originally trained to become an aircraft mechanic (a skill he later applied to power saws), Bob ultimately was attached to the 14th Army Air Corps Reconnaissance, which did the photographs for the famous Doolittle raid. Bob thus spent a great deal of time in the Far East, particularly in China. He met the famous General Chenault, and he began his collection of documentary photographs, the best of which he keeps in a blue metallic cigar box. These photographs were taken in the last days of the Chinese Republic before Chairman Mao came to power. The snapshots feature Chinese villagers, mainly children at play and peasant women with water jugs. There are also shots of waterfalls and village gates. The photos suggest a dirty, hard-scrabble world that had been ruined by war. The Japanese were only miles away when most of the photographs were taken. "Everything was nice except for the old Japs. They was hitting with those bombs every night." After the war, Bob returned to Shelbyville and helped in the family business, selling and repairing Whizzer Motor bikes as a sideline.

Then, in 1952, Bob was turned down by a credit manager at a local catalogue store when he tried to purchase a power saw. In a fit of pique, he wrote a letter to Homelite, asking for his own franchise. "That guy insulted me, but it worked out to my best interest." That was how he began selling the Homelite XL-12. When Homelite entered the outboard motor business, Bob tried selling that line only long enough to earn money for a boat and motor of his own. Then Homelite phased out its marine

23

products, and he became a Mariner dealer (as he is today). For each of the past five years, Bob Klauser has won Mariner's Best Dealer Award for the entire United States—not a bad payoff for enduring an insult.

The old downtown shop became too small to accommodate power boats, jon boats, canoes, and trailers, so Bob moved the marine side of his operation to his rural homestead, a few miles north of Shelbyville on Possum Creek road, near Lake Shelbyville and resorts like Coon Creek and Possum Creek that provide so much of his day to day business. At the time of our last interview, he had leased out the old downtown shop and moved his business completely out of the country, emphasizing the boat sales over guns, saws, and other sidelines. His new office, next to his house and a stone's throw from the boat showroom, still contained the giant work table and the antique clock, which, he informed me, was manufactured in 1869 and was originally owned by an ex-slave—the man who sold the downtown building to the first Klauser.

Yes, he does take photographs of his boat customers, too. Some people appear in both sets of photos. The boat pictures are color photographs, however, and their tone and content are quite a bit different from the early black and whites. Boats are considerably more exciting than saws, and these photos are primarily family shots, with lots of kids crawling over the equipment. Many photos show couples in tender, even passionate, embraces as if purchasing a boat somehow reinforced their romantic commitment to each other. Danny, Bob's son and chief boat salesman, explained it this way: "When they buy a boat, that's a family affair. They're looking to have a good time—when they buy a chain saw, they're looking to work. A boat means more than diamond rings to most people." Most of the customers are from central Illinois, but others hail from places as far away as Chicago, Indiana, Missouri, Montana, and California. "Every one's a story," Bob added and launched into two of his favorites.

One day a man arrived at the show room to inspect a second-hand .25 caliber automatic pistol. "He likes pistols," Bob continued. "I showed it to him. He brought his wife along, and she tends to nag a little and be bossy. I says, Edgar (not his real name), as long as you're out, you better come in and look at the boats. She says, 'He don't need to go in there and look at no boats. You're not gonna buy no boat.' I says, Edgar, you're gonna have to buy a boat to establish you're the boss. And he come in, and he ordered one. Four thousand dollar boat."

Another day a seventy-year-old man armed with a large knife appeared at the door. Sneering disdainfully, he announced that he wouldn't even have one of those boats, even if you gave it to him. After considerable wrangling and horse-trading, he bought a huge outfit with a 140-horsepower motor. He slept in the boat that night, right in the show room. Then the next morning, in unseasonably cold November weather, he took the

boat out to the lake, nosed it into Possum "Crick," donned his wet suit, and dove into the cold water to recover a lost tackle box!

Clearly, there are many links among the harness, saw, and boat businesses. All three enterprises responded to the natural environment and the activities of the people who worked and played there. Shelby County is rich in farm land, timber, and lakes: combines, saws, and outboard motors were inevitable. Bob used one of the power saws to create a sculpture of an Indian chief, whose prominent head (fashioned from a fallen elm tree) provided a memorable marker for the rural boat business. Just as Bob worked with Ned, so does Danny work with Bob. From the beginning, the land and the family members all interacted, and all the Klausers seem to wear at least two hats: Flora, Bob's wife, and Jane, his daughter-in-law, manage the secretarial and bookkeeping chores. Even Ruff, the family dog, doubles as pet and night watchman.

I admired the healthiness and openness of this family, their history of hard work, and their sense of fair play. In the old days, before we became a corporate nation of conglomerates and faceless multinationals, such family teams were the norm. In those earlier days Bob Klauser would have been called a tradesman, and, like today, many of his customers might have well been his friends or neighbors. I asked him if the marketing of chain saws by the big discount firms had ever frightened him. He answered in this way: "I've kept running more than what I've sold. A discount store would hand them a saw in a box. I've sold more saws since they started selling them than I did before. It kind of flatters you in a way, not that they went somewhere else to buy it, but that they have enough confidence in your integrity that they'll come to you to let you work on 'em."

It was getting dark now, long past supper time. Flora invited me to stay for supper while Ruff licked my hand. As we were walking towards the house, Bob took my arm and said, "I don't want it wrote up like I'm bragging about the whole thing because I'm not. I got the Lord's blessing. I just lucked out."

Mansions and Carriages:
A Walking Tour of Historic Old Decatur

To the harried motorist, shuttling along the concrete ribbon of Interstate 72, the city of Decatur looms as a distraction to the south, a skyline of towering smokestacks that send up giant plumes of snow-white steam. On frigid winter days, those plumes climb into the upper atmosphere, announcing to the world that Decatur is still a major processing center for corn and soybeans, as suggested by its nickname "Soy City." But the glory days have long since passed, and like most manufacturing cities in the Midwest, Decatur has felt the bite of foreign competition and the drag of the overvalued American dollar. Brazil has flooded the market with cheap soybeans, while the Japanese and Italians have undersold American cars and earth-moving equipment, leaving local plants, like Caterpillar and Borg-Warner, in precarious positions. Hundreds of workers have been laid off—some permanently—and during one recent reporting period, Decatur led the entire nation in unemployment. Every morning I drive by vast industrial parking lots that once were filled with workers' cars and now lie virtually deserted. Yet inventors and entrepreneurs once amassed great fortunes in this city (the fifth largest in Illinois), and between the time of the Civil War and the Great Depression, much of that wealth went into the construction of lavish personal residences, architectural legacies that can still be appreciated today.

Although Decatur was not linked to the interstate highway system until late 1975, the interstate motorists of today, lulled by the monotony of corn fields or cruise control, probably don't realize that the very first interstate *did,* in fact, run through Soy City. In 1914, the year that World War One began, Decatur motorists in their throbbing "horseless carriages" had direct access to the wonderfully muddy thoroughfare known as the Pike's Peak Ocean-to-Ocean Highway, which connected some five hundred cities. Promoters claimed that during the "touring season" (from April through November) a motorist could drive from Manhattan to Los Angeles in "only" seventeen days "without special exertion on the part of

the driver or undue mistreatment of his car." These connections with cars and motorways (as they were then called) helped to define Decatur and, in combination with the grain-processing business, to create its considerable wealth. One of the first automobiles seen in the United States was the "Benz Motorwagon," brought to Decatur in 1895 by Hieronymous Mueller, himself a famous inventor and industrialist. In 1916 the Comet Auto Company opened its doors in Decatur, producing six cars per day. The Comet was equipped with a fifty-horsepower engine and cost $1,185. The Comet Company soon shared the spotlight with the Pan American Motors Corporation, maker of the American Beauty Roadster, which was sold under the slogan "lives up to its name." By 1922 both companies went bankrupt, an eerie foreshadowing of today's "rust belt" economy in which scores of automobile feeder-plants and sub-contractors have literally been driven out of business by Nissan, Toyota, and Mitsubishi.

When James Millikin arrived in Decatur in 1856, there were no soybeans or automobiles, only a prosperous little community with genuine potential for economic growth. Millikin's genius lay in sensing that potential. He arrived with a hard-earned fortune of $75,000, which he had earned as a kind of eastern cowboy, driving herds of cattle (and sheep) from the hills of his native Pennsylvania for fattening and resale on the Indiana prairie. His local business ventures in Macon County earned him so much money that in four years he put out a shingle advertising himself as "J. Millikin, Banker." During his lifetime (1825-1909) Millikin gave over a half million dollars to various charities, and at his death he left one and three-quarter million dollars for charitable and educational endowments. The most important gift established a university which opened its doors in 1903 and, even today, still bears his name. A few blocks east of Millikin University stands the Millikin Homestead, the first structure in Decatur to be placed on the National Register of Historic Places (in June of 1974) and the only residence in Decatur to be mentioned in John Drury's classic book, *Old Illinois Houses* (University of Chicago Press, 1948). Without hyperbole, the Millikin Homestead can easily be called the most impressive building in Decatur and in Macon County as a whole. And during the time that Millikin lived in the mansion, he watched the nation go from horse-drawn to horseless carriages.

Begun in 1875 and finished during the Centennial Year of 1876, the Millikin Homestead was built for $18,000 on land that cost $2,200. Of course, in 1875 the services of a first-rate carpenter could be obtained for as little as $1.25 per day, and even master bricklayers were paid no more than $2.00 per day. Today, this large Italian-Victorian mansion, dominating several acres of lovely, landscaped grounds, is priceless. The Homestead contains seven fireplaces, each one unique in design and featuring the use of such materials as wood, marble, and stone. In fact, first-time

visitors will be overwhelmed by the sheer *richness* and *variety* of materials used in constructing both the interior and exterior of the dwelling. The interior features brass fixtures, art glass windows (etched with delicate tracery), stained glass (a delightful surprise as one mounts the staircase), and bird's eye maple in shutters and paneling.

The exterior could well serve as an architectural textbook, since it contains examples of virtually every important style or ornamental device. The distinctive tower with its high mansard roof is influenced by the Second French Empire, and the tower is further enhanced by an elliptical (or bull's eye) window. The double gables feature pediments with modillions (decorative blocks), and the east side of the house boasts a bay window of the oriel type (cantilevered and protruding from the wall). The roof features iron cresting on its peak, and the bay window on the north side is covered with copper. Millikin spared no expense in building this mansion: it was easily the finest residence of its day, at least in Macon and surrounding counties. What matters today isn't the architectural jargon or the monetary value of the house but the poetry of its presence, the way it hangs on the horizon, sitting like a small hill in a grove of venerable oak and maple trees. The eye delights in a thousand small and subtle pleasures as it follows the mixture of straight and curved lines, the arches, triangles, and ovals that define the overall form. There is pleasure, too, in the colors and textures of the Homestead. On a recent fall visit, I found the lawns fresh and green, the overhanging trees russet and pumpkin-colored, the red brick earthy and noble-looking, and the bluish-gray slate of the roof shiny and wet from the previous night's rain.

When I first visited the place (by special permission in the fall of 1973), pigeons had already mounted a full-scale invasion, leaving their telltale deposits everywhere. The halls were littered with rubble, the woodwork appeared weathered and cracked, and a sooty grime covered everything like the dust of the ages. By that time James Millikin and his wife, Anna, were little more than memories. He had died in 1909, she in 1913. They were a childless couple, and their personal lives were simple and austere. No grand drinking parties ever took place in the old Homestead. Occasionally, Anna held formal teas, and that kind of function nearly summed up the social activity of the place.

But in 1918 and 1919 the Homestead was turned into a hospital to care for victims of an influenza epidemic. In 1920, it became the Decatur Arts Institute, a role it continued to play until 1969, when it became vacant—and the pigeons moved in. But in 1975 the Junior Welfare Association of Decatur joined with Millikin University in a major restoration of the Homestead, with the University undertaking the maintenance of the grounds and the exterior of the building while the Junior Welfare Association began to perform a series of miracles on the interior. Many

local craftsmen helped restore light fixtures, woodwork, and windows. Authentic period furniture was located, and each room was restored to its original appearance. I happened to be visiting the Homestead a few years ago when the original Millikin silverware arrived. Picking up a heavy table knife, I felt oddly and intimately connected with the self-effacing and generous man who once lived in the place.

Now one can roam through the dwelling and get a sense of life as it was lived here a hundred years ago, with heavy carpets on the floors and patchwork quilts on the beds. I especially like the breakfast nook, a tiny room on the north side of the house, which in my inevitable fantasy becomes a writer's office with desk and word processor beneath the large window. I suppose every visitor must go through a similar act of reclamation, possessing—if only in the imagination—the small library, the spacious dining room, the cozy north parlor, or the large and well-lighted south parlor. In 1976, the Bicentennial Year, James Millikin Homestead, Inc. was formed, and in 1981 the restoration work was completed. The Homestead Association rents the home for receptions, meetings, and conferences, and conducts special tours. Hundreds of Decatur and area school children have visited the home, delighting in the gracious manners of "Mrs. Millikin," ably portrayed by Ruth Prust. Many other children visit the premises to take special arts and crafts classes regularly offered in the building that once served as Millikin's carriage house.

Millikin Place, the lovely lane that runs just to the north of the Homestead, was laid out in 1909 and was originally supposed to serve as a showcase for Frank Lloyd Wright's Prairie School designs. Unfortunately, Wright never completed the three houses he had originally planned to build (Numbers 1, 2, and 4 Millikin Place), but the blueprints for Number 2 Millikin Place do contain Wright's signature. Wright left for Europe in September, 1909, turning the Millikin Place project over to an associate, Hermann von Holst, who subsequently hired Marion Mahony. Miss Mahony had served as Wright's chief design artist, and she is usually credited for adding the brick piers at the front of the house (which did not appear in some of the early plans). Miss Mahony also designed the dining room table and chairs, which are still part of the house. In fact, the strongest feature of Number 2 Millikin Place (usually identified as the Irving House) is the wealth of tiny domestic touches, all prescribed by Wright's original plan, like casement windows with insets of stained glass, a special clock designed for this house alone, built-in bookshelves, a built-in sideboard, and even a built-in table-desk.

Viewed from Millikin Place, the Irving House seems like a typical early Frank Lloyd Wright production, with the gentle angles of its roof line, the oversized chimneys, grossly exaggerated roof overhang, and the dramatic horizontal stress of the total design, emphasized by rows of

windows arranged in modules. Wright's homes of this period seem to be a compromise between the boxy, big bungalow style that dominated middle class Illinois architecture around 1900 and the later, radically low-slung homes he created, like the Robie House (now part of the University of Chicago campus). The Irving House in Decatur seems altogether right (no pun intended) in its setting, a perfect expression, as the master had planned, of sweeping prairie lines and earth tones of sand and loam. The more one looks at it, the more it seems to have sprung, fully formed, from the ancient soil beneath its feet. It belongs as the earth and the sky belong, in depth and height and breadth that fill and overflow our meager field of vision.

A few hundred feet to the north and east of the Irving House stands the Ferry-Cruikshank House (861 West William Street), erected in 1917, the year that the American Expeditionary Force entered World War One. It suggests a grandeur and opulence on the scale of a European villa, the kind of imposing structure that early Hollywood moguls constructed on choice pieces of real estate throughout southern California in the decade of the Roaring Twenties. The Ferry-Cruikshank House might even have served as the model for Xanadu, the fantasy mansion in Orson Welles' classic film *Citizen Kane*.

The Ferry-Cruikshank House might be formally described as Italian Renaissance in style—or informally as Italian Villa style. It is the first fireproof residence to have been constructed in Decatur, and it contains a hotel-like interior, with seventeen rooms, a bathroom for each bedroom, two sleeping porches, and a solarium. Its tawny brick exterior is nicely complemented by a Spanish-style roof of heavy green tile. Despite its grandeur of scale, the house is remarkably cozy-feeling: the vestibule seems to enfold the visitor like a protective garment, inviting the new-comer to enter the spacious hallway and enjoy the huge wood-burning fireplace, the molded plaster ceiling, and the glinting lights of stained-glass insets in massive casement windows.

It just so happens that Richard Ferry, the present owner of the house, is a poet and a connoisseur of the architectural splendors in his immediate neighborhood. In his little chapbook, *Street of Mansions* (Red Herring Press, 1983), Ferry articulates the marvelous mixture of fact and fantasy that surrounds these old houses:

> I try on old houses like clothing
> getting them so snug I don't know
> where I end and the houses begin.

And he captures the special atmosphere of Central Illinois, the character-istic light that enhances every detail of these dwellings:

More and more of the prairie seeps inside
where the sky pours sun on fern and palm pots
arranged around the sunken tan-tiled floor
before the wall of a sunburnt fireplace
lavender grouting bricks arranged like an open fan.

Ferry's poems remind us that houses *are* art objects, and houses of this magnificence amount to outdoor museum pieces, aesthetic treasures that are free to any sensitive observer. The community benefits from a common resource of beauty, something every citizen can enjoy. Beautiful buildings are worth fighting for because, without them, our world would surely become squalid or monotonous—as suggested by the dilapidated buildings of most inner cities, the ugly boxes that pass for condominiums, and the waferboard houses of suburbia. How lucky we are to have so many historic homes in Illinois, a fact well appreciated by the Decatur Area Arts Council and the Decatur Historical and Architectural Sites Commission. These two organizations pooled their efforts to produce three pamphlets entitled "Historic Decatur: Walking Tour 1,2,3." Each pamphlet contains maps, photographs, and a self-guiding walking tour of Decatur's Historical District. Some forty-one separate buildings are included in the tour. Walking is important because the houses really can't be appreciated behind the windshield of a moving car. Besides, the simple act of walking returns us to the pace of an earlier era, when pedestrians, horses, and carriages threaded their way through the shady back lanes and tree-lined avenues of the district. Every time we admire these old structures, we make a private journey to the past, and in so doing we expand the resources of our sometimes diminishing present.

A few blocks east of the Ferry-Cruikshank House, along the brick-paved surface of West William Street, stands the Richard J. Oglesby Home (421 West William), one-time residence of Decatur's most famous citizen. Built in 1874, when Oglesby was already well established as a political figure, the house is not quite on the scale of the Millikin, Irving, or Ferry mansions, primarily because the grounds are smaller and the structure is set closer to the street. It's a grand old two-story home, nevertheless, with distinctive brackets under the eaves which remind me of giant mantel pieces. The interior is high-ceilinged and boasts floors with dramatic alternating planks of walnut and maple. The library floor is justly famous for the intricacy of its parquet, and the exterior windows still contain diamond-shaped panes.

Of course, it is the original owner of the house who claims our greatest attention. For Richard J. Oglesby, the first three-term governor of Illinois was, like the house that bears his name, a little larger than life, designed on an over-sized scale with uniquely flamboyant features. "I came to Illinois," he said, "...a buxom, frolicksome, young ass. Why I never

heard of a night shirt until I was thirty years old." Oglesby was a born adventurer. After being admitted to the bar in 1845, Oglesby briefly practiced law, but he headed west in 1849 to participate in the California Gold Rush. Two years later he returned to Decatur $10,000 richer. Eldorado Street (also U.S. 36 and the northern boundary of the historical district) derived its name from Oglesby's gold digging. He used part of that money to free a former family slave in Kentucky, and later as governor his strong anti-slavery views help to make Illinois the first state to ratify the thirteenth amendment prohibiting slavery. In 1856 Oglesby made an extensive tour of the Holy Land. Afterwards, he remarked, "What a strange thing anyway, this whole matter of life is."

Closely connected to Abraham Lincoln, who often came through Decatur on legal business, Oglesby was one of Abe's staunchest supporters. Oglesby was the man who invented the slogan "Lincoln the Railsplitter for President" when Lincoln was first nominated for the presidency at the state Republican convention held in Decatur in May, 1860. Richard Oglesby just happened to be in Washington, D.C., on the night of April 14, 1865, but he declined an invitation to accompany Lincoln to Ford's Theater. Oglesby was soon at Lincoln's bedside, however, and remained there until Lincoln died the next morning. On October 15, 1874 it was Richard J. Oglesby who gave the dedication speech for the Lincoln monument and tomb, a final, official farewell to his most famous friend.

If Oglesby were alive today, he'd be pleased to see the restoration work on his former residence, and I'm sure he'd take comfort in the presence of the Millikin Homestead, which was built only a year after his own residence. As a beneficiary of the instantaneous wealth available in the California Gold Rush, he might have had a hard time understanding our sluggish rate of growth, our high rate of unemployment, and the ugly blight of urban decay. Then again, he might rejoice in Decatur's new Civic Center, the trendy shopping mall on the north side of town (Hickory Point), and even the new "pike" of Interstate 72. But I'm guessing he'd crave a well-curried horse, a smart little carriage, and a beautiful autumn afternoon to linger over grand old houses that belong to the real world and the dream world. We, too, could join him in savoring these solid symbols of a bygone era, dwellings of the body and the mind that, after all these generations, clearly deserve the title *works of art*.

Steeples and Silos

In a world made gently undulant or mathematically flat by the grinding action of glacial moraines, steeples and silos still rake the horizon like tall-masted ships or miniature skyscrapers. They adhere to a small family of stark, vertical presences that cut dramatically across the line of sight: grain bins, elevators, weather vanes, and windmills. They are architectural expressions of humankind's oldest needs: food and religion, god and grain, essential sustenance for body and soul. Long before Frank Lloyd Wright insisted on a long, low "Prairie Style," our first pioneers raised voices and roofbeams upward to the sky. Their collective gratitude for rich and bountiful harvests was seemingly focused to a point and funneled upward through the steeples of the little churches that marked even the poorest settlements on the prairie.

All summer long I was haunted by the ghost-images of Midwestern churches and farm buildings. Living on the prairie has permanently altered my mental circuitry so that I can't spend time in Maine or Louisiana or New Mexico (as I did this summer) without making constant reference to the red barns, white churches, and silver-capped silos of the heartland. Even two years ago, when I was taking a course in South Yorkshire, England, I found myself unconsciously scanning the sheep meadows and downs for the familiar form of an Illinois barn or silo. In Bangor, Maine, and in all the postcard-perfect villages that line old U.S. Route 2 and U.S. Route 1 (an asphalt snake that follows the coastline up to Canada), I studied the barns and the churches. Those little New England churches would be unthinkable without their sharp steeples— Bangor boasted many, including one with bronze and copper trimming. These venerable houses of worship, however, gave off an air of unyielding righteousness that seemed entirely foreign to the farmers of the plain little prairie churches.

I noted that difference, too, in the French Quarter of New Orleans, where St. Louis Basilica dominates historic Jackson Square. Three steeples surmount this grand old church, an exotic blend of French and Spanish

religious architecture. At the other extreme, I considered the steeple-free adobe church in the Indian pueblo at Taos, New Mexico, a white-washed, round-shouldered building executed in a simple style that has been used successfully for over 2,000 years. Yet in this world of mesas and mountains, in the very places where artists like Georgia O'Keefe and Ansel Adams had worked so persuasively with painting and photography, some renegade part of me longed perversely for the stark symbols of the prairie. As much as I loved the roads through the mountains and the footpaths through the canyons, I still craved the straight county roads and the straight-lined churches, often facing east, lining up on the invisible points of the compass.

In 1875 an English Catholic living in the Shelby County area, apparently homesick for his parish church in England, donated the land where St. Mary's Methodist Church stands even today, although much altered in form and purpose. A typical, white-framed prairie church with a fine, sharp steeple, St. Mary's was the seat of worship for one congregation after another until it finally closed as a church in 1971, the last congregation joining the Methodist church in nearby Findlay. Although steeples are structures primarily designed for bells and bell-ringing, St. Mary's had no bell during its entire lifespan; and, in its later years, the steeple became so dilapidated (a common problem) that it sorely needed a craftsman's healing touch. Alas, no one could be found with expertise in steeple repairs, so the upper part of the steeple was simply removed, leaving a somewhat awkward and truncated facade. But the story of St. Mary's does not end with the sawed-off steeple, because after it was vacated by the congregation, St. Mary's became Church Mouse Antiques, a successful little business open every weekend to motorists driving by on Illinois 128—a perfect example of what architects like to refer to as "adaptive re-use." As I watch the customers reverently examining paperweights, antique tools, sugar bowls, toys, and rocking chairs, it occurs to me that a worshipful reverence still persists on the premises—if not for the godhead, then at least for the golden years evoked by all these old artifacts.

Following Route 128 south leads one directly into Shelbyville where the little brick church of the Immaculate Conception proudly raises its tower-like steeple and distinctive, red-painted roof. Built in 1879, the snug little church not only serves the local parishioners but also many campers who are visiting one of the many campgrounds around Lake Shelbyville. The tower-steeple of Immaculate Conception is neatly echoed by the larger tower atop the Shelby County Courthouse, a structure immediately adjacent to the old church building. Still another courthouse with a steeple-like projection may be found in Taylorville, county seat for Christian County.

All the steeples and towers on the prairie aren't necessarily milestones; there are humbler versions on a more human scale, like the short, squat steeple atop the Mount Pleasant Church of God (Route 29, Shelby County) or the true bell-tower crowning the white frame structure of St. Mary's on Route 104 in Pawnee. If you enter Pawnee from the west, there is even a Hail Mary billboard by the roadside. Painted in baby blue, it seems at first like any other highway sign. I absentmindedly read half of it before I realized it was a prayer. Then I pulled over and completed the text. In a week where too much of the news had been bad (deficits, foreign buyouts of Illinois farm land, cutbacks in already hard-pressed school districts), a little Hail Mary by the roadside did not seem like such a bad idea.

Worship doesn't occur just in quaint, rural settings, however, as the existence of Church Street in Decatur eloquently suggests. In the space of about two blocks one encounters three superlative examples of urban religious architecture: First Presbyterian Church (built 1890) with a 100-foot-tall bell tower of Indiana sandstone; First United Methodist Church (built 1906), a domed structure rising 110 feet above ground level, a building that ultimately owes its existence to the radical circuit-riding preacher, Peter Cartright; and St. John's Episcopal Church, one of the loveliest churches in central Illinois, a replica of a thirteenth-century English Gothic church, constructed of red sandstone from Iowa and Wisconsin. Just east of St. John's on Eldorado Street (Route 36) stands St. Patrick (built 1909) a magnificent Gothic structure modeled on Salisbury Cathedral in England. Its tower and steeple, appropriately topped with a cross, soar 150 feet above the prairie. Recently, one of my colleagues invited me and others to celebrate the marriage of his daughter at St. Patrick, and after the ceremony we stood on the steep, Gothic-styled steps with our little bags of rice, waiting to blitz the lucky couple in a shower of white grains.

Springfield has so much government-related architecture and monuments that it is easy to overlook its fine churches. I will mention only my two favorites. The Cathedral of the Immaculate Conception does not possess the typical prairie-styled steeple of the rural churches, but its stolid, formalized exterior blends handsomely with the nearby buildings of state officialdom. The earthy sandstone exterior divides neatly into bottom and top sections. The bottom consists of true Doric columns with a classic, Greek temple facade. The top portion erupts in graduated leaps of stone, creating a three-tier Italianate steeple. I also admire the tripartite design in the Cathedral Church of St. Paul, the Episcopal church at Second and Lawrence. It offers another example of English Gothic in central Illinois, even including mock flying buttresses. On the first tier of its facade, St. Paul has a typical Gothic doorway with pointed arch; on the second tier, a statue of St. Paul in an enveloping stone niche; and on the

third and topmost tier, louvers for the bells, all surmounted by a solid stone cross.

So the heartland becomes an excellent place for all kinds of harvests, a heap of good intentions and booming hymns on Sundays, bins bursting with grain and silos packed with silage on the other days. And a diversified secular-agricultural architecture evolved side-by-side with the religious architecture, with the resultant structures standing in close proximity, silos and steeples all over the flat land.

Silos are part and parcel of dairy and cattle farming and evoke a richer, more diversified, low-tech, low-yield (and also low-erosion) style of agriculture. A few years ago the famous anthropologist Margaret Mead made one of her last speeches at Illinois State University. She observed that in the twenties Illinois farms were still small, family affairs. Each farm was self-sufficient, producing its own eggs, butter, poultry, pork, and vegetables. Today, by contrast, we often have tenant farmers who eat over-salted canned goods or TV dinners on a farmstead with no livestock or chickens. The reason silos are fading from the scene is that real, live cattle have largely disappeared from central Illinois, especially dairy cattle. Only the Amish community around Arthur still relies on animal power, and even some of the more "progressive" Amish and Mennonites are fast abandoning Bossy and Old Dobbin. The only time of the year that farm animals seem to emerge in sizable numbers is during the judging days at the State Fair.

In the old days, however, or at least up until World War II, there were still vast numbers of farm animals—and they all needed to eat, especially during the cold, stressful winter. Farmers needed ready and reliable storage units for draft horses and mules as well as cattle, hogs, and, to a lesser degree sheep. For thousands of years, farmers had been in the food production and storage business, so it is not surprising that local farmers had devised a number of low-tech strategies for coping with these problems. Chief among these improvisations was the humble corn crib (another piece of fast-disappearing agricultural architecture). Corn cribs became obsolete when sheller-pickers and, later, combines did all the work that used to be done by hand: picking, shucking, and storing in the corn crib—or in any building that could conceivably hold the overflow of those bountiful years. Corn cribs are basically sheds or small barns constructed with slatted sides, allowing free-flowing ventilation to dry the corn. What many city slickers identify as a "barn" is, in reality, a corn crib. Corn cribs naturally attracted hungry mice, rats, racoons, and deer; thus, farmers hoped for the handy assistance of the common black snake who ate the rats that ate the corn. Here is how Byron Halsted described the self-feeding corn crib in his little classic, *Barn Plans and Outbuildings* (1881):

In portions of the West, where corn is mainly fed to stock in the open field, a crib may be used which will not only store the corn, but will supply it to the stock as they may need it, without any further handling than merely filling the crib. Corn being very cheap, and labor dear, it is an object to save labor at the expense of the corn.

Dairy cattle required especially nutritious diets, and silage served their needs better than mere hay or corn alone. The word silo is French for "pit," and the first silos were really pits or trenches (lined with wood, stone, or tiles) filled with finely chopped green corn to which water was added. This mixture was packed under pressure and sealed airtight so that it quickly fermented, providing a rich—and heady—foodstuff for Elsie and all the other dairy cows. Larger operation required larger silos, like the lovely leaning silo on the Wayside Farm just north of Assumption in Christian County. Presently owned by Vivien and Carl Wendling, the farm previously belonged to Vivien's mother. All the outbuildings burned down during the fateful year of 1929, when Vivien was still a little girl. The present silo was constructed in 1929 from special silo tiles glazed and fired to a shiny brown finish. Each row of tiles is reinforced by a steel belt, which can be tightened with a turnbuckle. The silo is attached to the dairy barn. Both are empty now, yet they once supported a thriving dairy operation that utilized milking machines and a large milk cooler. Today, Wayside Farm mainly produces corn, and I peered inside one of the galvanized steel bins that will contain the harvest, or at least 20,000 bushels of it, stirring it gently with three long rods, and removing moisture with gas heat and an electric blower. Obviously, we have come a long way from the days of the black snake.

Vivien was clearly proud of the place and was investing in its preservation by having the barn covered with vinyl-covered aluminum siding. The old and the new kept coming together, but I must admit a weakness for the old blacksmith shop, for the weather vanes (in the shapes of arrows and cows), and for the old lightning rods with their fancy, glass-ball ornaments. By contrast, Martin Vota's farm on Route 104 west of Taylorville was smaller and less decorated, but he, too, was saving the place—with paint, on the cloudy afternoon I visited. His silo and dairy barn were somewhat smaller and cruder, but they served the same purpose as the larger ones. Martin's brother had once raised eighteen dairy cows on part of the land, farmed the rest (corn and soybeans), and, during the fall and winter months, worked in the coal mine which ran along the boundary of his farm. Martin pointed out that we were in coal-mining country, too, especially around such hamlets as Tovey and Sicily. We leaned on a forty-year old Ford tractor, Model 8-N, the same one used long ago by his brother (and still in perfect running order), and I was hit

in the center of my being by the essential up and down of things. Men had been digging coal practically under our feet, and all around us the beans and corn were curing themselves in a hundred tones of amber and brown. The sky glowed pink, holding its color in that dry, clear light that floods down on us each September. I suddenly imagined the lost dairy cows, this silo, and every old silo in the country bursting with 100-proof silage, every church steeple joyfully ringing its bells, and something bright like angels going up to the sky, in this unhurried old place we so rightly call the Heartland.

Living with Lincoln

On a recent trip along the east coast, I stopped for a few days in Arlington, Virginia, staying at a hotel just within sight of the Pentagon and the Arlington National Cemetery. Inevitably, I found myself wandering around the pleasant hills and groves of the cemetery, admiring the Eternal Flame of John F. Kennedy's tomb, the little wooden cross that marks the site of his brother Robert's grave, and the ceremonial changing of the guard at the tomb of the Unknown Soldier. The honor guard marched with doll-like precision, performing a kind of military ballet in blue uniforms and brass buttons.

On my final visit to the cemetery, I was drawn to the Greek Revival house on the highest hill in Arlington. This plantation-style mansion, known as the Arlington House, was once the home of Robert E. Lee and Mary Custis Lee. The home and the adjoining grounds were confiscated shortly after the outbreak of the Civil War and ultimately became the property of the federal government. The portico on the east side of the Arlington House affords a panoramic view of Washington, D.C., and was, in fact John Kennedy's favorite vista of the Capital City. I stood there on a statistically rare and cool day in early August, admiring the milky green Potomac, the dome of the Capitol, and the metallic gray obelisk of the Washington Monument. When Abraham Lincoln first assumed office as president, the dome of the Capitol Building was still unfinished, and the Washington Monument was no more than a pile of rough stone—fitting symbols for the unfinished state of the nation and of its new president. During the whole trip I had been fishing around in my duffel bag, pulling out my dog-eared copy of Gore Vidal's *Lincoln*, and re-reading my favorite underlined passages. Vidal emphasizes the physical condition of Washington at the time Lincoln became president (the unfinished monuments, the muddy streets, and the foul-smelling canals), and I found myself living simultaneously in the present and the past. Everything seemed to focus on Lincoln, the one great hub on which all the spokes were attached.

In the next week or so I would behold the Declaration of Independence, the White House, the Liberty Bell, and Independence Hall, but it was Lincoln, old Abe Lincoln, who dominated my thoughts and imagination. Even the glitzy, high-tech wonders of the Air and Space Museum could not dispel the image of the solitary home in central Illinois, that little spot on the globe where Lincoln rode the unpredictable terrain of the Eight Circuit. Within that orbit he became a man, a lover, a surveyor, a lawyer, a husband, and, finally, a president. Perhaps that is why I spent so much time at the Lincoln Memorial, hoofing my way down there from the Library of Congress up on Capitol Hill. Perhaps that is why I lingered at the Lincoln Memorial Bay of the Washington National Cathedral, a little alcove that contains my favorite statue of Lincoln. Shawl around his shoulders, Lincoln in bronze is giving his farewell speech to Springfield, and the words of that warm and poignant message are carved on the stone wall behind the statue. These lines are my favorites: "No one, not in my situation, can appreciate my feeling of sadness at this parting. To this place and the kindness of these people I owe everything. Here I have lived a quarter of a century and have passed from a young to an old man. Here my children have been born and one is buried. I now leave not knowing when or whether ever I may return...."

Even in Philadelphia, the City of Brotherly Love, I could not escape the presence of Lincoln. I ate dinner at Bookbinder's, one of the oldest and most famous restaurants in the United States. After the red snapper soup and crabmeat au gratin had induced a pleasant state of euphoria, I began to explore the ambiance of this fine old restaurant. Bookbinder's was opened in the last year of the Civil War, and on the second floor I was startled by a group of black-framed newspaper clippings, all original documents, yellowed and cracked with age. There were photographs of Lincoln's steely-eyed pallbearers as well as stories of the assassination itself and the funeral train back to Springfield. Bookbinder's began to operate in the last few days of Lincoln's administration, but his eerie presence had endured—and once again I was living with Lincoln.

Actually, I had been living with Lincoln for some time now, carrying him along like a pack on my back, seeing him in my imagination, convincing myself that the world was better defined and more solid underfoot because of this long-gone historical figure. Real history must be living history. Lincoln lived for me as a man on horseback, following the worst roads in howling winter weather, covering his face with a shawl, and seeking shelter at inns where the water pitcher turned into a solid chunk of ice by early morning. Lincoln also lived as the ghost-like figure who spent nights of insomnia in the White House while the nation practically bled itself to death. Yet Lincoln was slow in coming to me, and I to him.

My first weeks in Illinois (in the summer of 1972) had left me reeling. I experienced an agonizing case of culture shock, and I suffered constantly from a profound sense of dislocation. No antidotes were available for this particular ailment, or so it seemed. I became cranky and suspicious, looking for some precious place where I could relax and feel at home. Psychologically, I was making myself into a displaced person when, by accident, I chanced upon an official state map. Lincoln Trail Homestead State Park appeared as a little red tree above the blue thread of the Sangamon River—mapmaker's symbols that became vividly real to me over the next twelve months. None of my new acquaintances could direct me to the place, but I blundered there on my own, in the full heat of midsummer. The vines and hedgerows were thick, the surrounding cornfields seemed impossibly high, and the Sangamon River had vaporized down to a silvery trickle on the rocky river bed below. I stood high on the north bank, on top of the bluff where Lincoln and his family arrived in 1830, cleared some fifteen acres, and hastily threw up a cabin, barn, and smokehouse. Here was the place where the prairie opened up for me.

I began returning there every week or so, photographing the Sangamon from the top of the bluff, taking care to position myself in precisely the same spot. I can now project the finished slides rapidly on the screen and give myself the illusion of time-lapse photography. Sagging green willows and sycamores turn ochre and mustard; oaks become rusty red. Snowflakes begin to appear magically in some of the pictures as the river water gradually rises. Finally, the Sangamon freezes, and the snowflakes accumulate into drifts. The trees become ugly black limbs glazed with ice. The photographs for the next weeks all look the same until a certain brightness is discernible in the atmosphere. Something like a gray-green haze is forming in the crowns of willows. A single redbud ignites like a flare on the south bank. Violets and the shoots of May apples grow right down to the shore. Soon the corn is sprouting, and another year has passed upon the seemingly eternal prairie.

I began taking my students to this spot, reading them passages from Carl Sandburg's *Abraham Lincoln: The Prairie Years.* We'd ride out in the university van, and I would endure good-natured ribbing about my "hang-up" on Lincoln. They insisted that, as college students, they were "burned out" on Lincoln, yet they were visibly moved by the beauty of the place and Sandburg's graphic descriptions. He reminds us that the first winter in Illinois was especially hard on the Lincolns; they just happened to arrive in time for the Winter of the Great Snow, when four feet of snow and ice covered the prairie;

> Wolves took their way with deer and cattle who broke through
> the crust and stood helpless. Fodder crops went to ruin; cows,
> hogs and horses died in the fields. Connections between

houses, settlements, grain mills, broke down; for days in 12-below-zero weather, families were cut off, living on parched corn. Those who came through alive, in after years called themselves "Snowbirds."

Of course, the Lincolns endured all these discomforts in a drafty, mud-chinked cabin, heated by a single chimney. On July 5, 1975, as a Bicentennial Project, the Decatur Kiwanis Club dedicated a replica of the cabin, so now even the casual visitor can quickly visualize the Lincoln's "spread."

The Lincolns departed after that terrible winter—Abraham going to New Salem, while the rest of the family settled in Coles County. But the location continued to attract other settlers, especially Sheldon and James Whitley who, in 1843, dammed the Sangamon and operated a mill on that spot for several years.

James Whitley is buried in a tiny graveyard in the park, and I report sadly that most of the fine old tombstones (carved with angels and rosettes) have been vandalized over the years. One of the remaining headstones belongs to "Samuel J., infant son of J. & A.A. Matthews DIED Aug. 25, 1871 Aged 7 ms. & 14 ds." So the place positively reeks of history, both the public and the personal kind. An even older history, however, must be contained in the coils and pools of the Sangamon, where, at the end of Indian Summer, the coppery light is filtered through layers of shadows, dust motes, and odd refractions in the water until it is hard to tell where the light stops and the water begins. Giant trees make symmetrical images of themselves in the still water, like inkblots in a huge Rorschach test. I've hiked in all directions from this park, sighting wood ducks, geese, foxes, and (for three years) a muskrat who would swim out to the strongest point of the current and hitch a free ride on the Sangamon, floating lazily back to his lair under a yellow clay bluff. One spring a heavy flood wiped out all traces of this nimble swimmer, and, like most of the residents, he disappeared without a trace.

Lincoln must have been touched by the poetry of this place. Of course, he had no time to write down his verses in the busy months of 1830, but many years later (in 1846) Congressman Lincoln felt "a little poetic" one evening and composed these lines:

The very spot where grew the bread
That formed my bones, I see.
How strange, old field, on thee to tread,
And feel I'm part of thee!

Sandburg tells us that even in the summer of 1830, when the cabin and barn were being constructed, Lincoln's literary gifts were obvious. He made speeches to "trees, stumps, rows of corn and potatoes, just practic-

ing, by himself." In fact, he gave his very first political speech during that summer of 1830, at a Whig political meeting in front of Renshaw's Store and Harrell's Tavern. Today the spot is marked by a statue of the young Lincoln in homespun clothes. The statue was erected in 1968 by the Decatur and Macon County Heritage Committee and stands at the mapmaker's center point for Decatur: the intersection of North Main and East Main.

A larger and more pleasing version of the young Lincoln is portrayed in a statue that is just barely visible from my office window in Liberal Arts Hall on the Millikin University campus, the statue overlooks West Main Street, which was once the old stagecoach road to Springfield. In this statue Lincoln is depicted as a handsome young man resting on a stump. He is wearing homespun trousers and a tunic-style shirt, wide belt, and heavy work boots. The rail-splitting axe rests at his side. Erected in 1948 by the Memorial Commission (under the governorship of Dwight H. Green), this bronze statue is some ten feet high and rests on a large pedestal of pink marble. I have gazed at it thousands of times over the past thirteen years, perhaps the most obvious example of my living with Lincoln.

As a friend of mine reminded me recently, "If you turn up a rock in central Illinois, you're bound to find something about Lincoln under it." And that quip seems true enough, for I am surrounded by Lincoln memorabilia. A few blocks east of my office stands the home of Richard J. Oglesby, the man who invented the motto, "Lincoln the Railsplitter for President." And a few blocks east of his home, imbedded in a sidewalk near Central Park, is a little brass plate reminding the pedestrian that the state Republican Convention was held here (on May 9, 1860), and in a mock teepee Lincoln was first-nominated for the Presidency of the United States. Lincoln made frequent stops in Decatur, not just to conduct his legal practice but to buy his favorite loaf of bread from a baker who operated where the Sears store now stands.

Last winter I visited Mount Pulaski several times while conducting writing workshops with school children. I found a few moments to poke around the old court house on the square, a building which had been moved there, and one in which Lincoln had practiced. The court house has been turned into a kind of museum with authentic pipes, pens, ledgers, and candleholders from the pre-Civil War days. The curator showed me around enthusiastically and professionally, as if I were the very first visitor. We were the only two people in the old building on a cold afternoon. Upstairs, we admired the old court room itself, and then she stopped abruptly, grabbed me by the arm, and said, "You're standing exactly in the spot where Abe Lincoln once stood." Her voice nearly cracked with emotion, and I knew that at least one other person was living with Lincoln.

43

I had supposed that Lincoln relics were pretty thin in Shelby County where I live, but I learned only recently that Lincoln frequently visited Shelbyville, staying at the Tackett Hotel, which stood just east of the present Shelby County Court House, itself a landmark in the area. Apparently Lincoln would put down considerable orders of ham, eggs, and turnip greens when visiting the Tackett House, and according to the oral tradition that has come down through the Tallman family (which ran that hotel), Lincoln dressed simply in a graw shawl, homemade white cotton shirt, and the inevitable black suit. In 1927 a marker was placed on the southwest side of the court house as a memorial of Lincoln's visits to Shelbyville. The Tackett Hotel has long since been torn down, but after Lincoln's assassination it was renamed the Lincoln Hotel.

By now it seems rather obvious that Lincoln plaques, markers, statues, and namesakes (towns, colleges, motels) are so ubiquitous as to render the actual man of flesh and blood invisible. Like the great ideas of democracy and freedom of speech, Lincoln is everywhere, and everywhere ignored. I must confess that I probably would have missed him entirely were it not for my peculiar orientation. When you grow up in Dixie, as I did, Lincoln is not exactly a household word. There, the Civil War statues commemorate General Beauregard and Lee—what a shock it was for me to see the statues of the "other side." How ironic it seemed, at first, to be teaching "Yankees." Hadn't our great grandfathers shot one another in a bloody civil conflict? Didn't Lincoln and Grant both come from Illinois? One of my brothers-in-law put the matter simply a few years ago when he asked me, "When are you going to quit living with those Yankees and come back to your own people?" I can still remember chums of mine in elementary school who could produce, at a moment's notice, detailed maps of all the great Civil War battles, especially Bull Run, Vicksburg, Shiloh, and Gettysburg. When I left the South, I considered myself a liberated Democrat, and I thought all those regional and sectional differences were so much hooey. But I soon discovered that my old roots went deeper than I thought, and my new roots gave me a strange and somewhat contradictory identity.

Living with Lincoln has taught me how to cope with myself. Here was a man whose family originated in Virginia, who was born in Kentucky, who lived his adult life in Illinois, who fought to preserve the Union, and who eagerly desired a rapprochement with the South when his life was cut short by a third—and successful—assassin's bullet.

Lincoln had left the high bluff over the Sangamon and wound up on a flatboat headed for New Orleans, the city where I grew up. My mentor in graduate school (at Tulane, in New Orleans) was himself a graduate of the University of Illinois who had grown up in Harvard, Illinois. His sister still lives in Gibson City. One of my best friends grew up in Wood River, and

he now teaches history in Tampa, Florida. We often exchange letters on our ironic relocations, but when we do get together to talk we have a marvelously whole vision of the world we inhabit, not blurred by the fuzzy labels of North or South. I don't know how many times I've followed the meandering Mississippi down to the Gulf where I grew up. The trip down and back again becomes a kind of loop, a circle in my mind, with no clear beginning or ending. Where, exactly, does the North begin?

Now I think of the whole region as the Mississippi Valley, a place big enough to contain the likes of Samuel Clemens, Abraham Lincoln, Ernest Hemingway, and William Faulkner—and small enough to offer quiet and intimate spaces for people like me. I think this Heartland is bigger and more beautiful than we may have supposed. Maybe I'm old enough now to appreciate this American continent, maybe I'm hopelessly in love with rivers and trees and birds, and maybe I've just been living with Lincoln.

Spoon River Revisited

On Columbus Day Weekend I found myself trucking along Illinois 97, participating in that ritual tour known as the Spoon River Scenic Drive. High on my own expectations, I fell into a kind of Fall Fantasy in which a Walt Disney-style Jack Frost (complete with buffalo plaid shirt and glistening silver beard) would flourish his magic paintbrush and perform sparkling color magic on all the maples, sweet-gums, oaks, sycamores, cottonwoods, and sassafras trees that line the banks of the Sangamon, Spoon, and Illinois Rivers. But old Jack Frost wasn't on duty this year, or his magic was strangely impotent because the trees shone resplendently green and spring-like, the result (no doubt) of fifteen consecutive days of tropical heat and nasty little squalls that boiled up out of the gray mass and dumped inches and inches on hapless Illinois. Northern Illinois was officially declared a disaster area, and even here in the pocket-sized valleys and marshy bottomlands between the three rivers, there was muddy evidence of flooding in the high-water lines on trees and road signs and barns. All of those slick advertisements to the contrary, Illinois was not putting us in a happy state.

Abnormal weather patterns, then, primarily accounted for the poor quality of autumnal hues because chemistry and photosynthesis had more to do with the panorama of the landscape than Old Jack Frost or folksy agents like wooly caterpillars or the rise and fall of "sugar sap," as one of my rural neighbors likes to call it. I vaguely recalled my college botany course, and I realized that the chemical clocks had failed to tick this year. *Chloroplasts* (those color-causing pigments), especially the *carotenoids* (those producing tones of yellow and orange), simply weren't ready to make rusty-red oaks, flaming maples, or grand lemon-colored sycamores. I contented myself instead with the brilliant displays of fall vegetables at the ubiquitous road-side stands: bloody-red turban squash, jumbo pink banana squash, burgundy-colored Indian corn, tawny butternuts, and enough piled-up pumpkins to satisfy my craving for the customary orange of October.

In a way, however, my small disappointments whetted my appetite for the deeper and more sustaining pleasures of the region. This country owed its fame, after all, to the overwhelming presences of Abraham Lincoln and Edgar Lee Masters, ruling like ancient divinities over the few miles of terrain from New Salem to Petersburg. I had come for this culture, the historic culture of the region, so I endured the bumper-stickers, the sidewalk sales with pawed-over blue jeans, the half-eaten hot dogs trodden under foot, and the old Simonized Chevvies parked proudly on the courthouse squares. It was "Victorian Days" in Petersburg and "Oktoberfest" in Lewistown, the two places that served as the boyhood homes of the poet and the parameters of that imaginary place he called "Spoon River" in his American classic, *Spoon River Anthology* (first published in 1915). I cheerfully conceded the right of the city fathers to attract attention to their towns, and I acknowledged the right of the local merchants to peddle their wares on the thoroughfares. But I wanted to hear something besides the amateur country and western vocalist or the insistent street noises and tinny car horns. I craved the music of an older, simpler Petersburg, "built upon some hills"

> That hem the square of stores and mills,
> Lumber yards, wagon shops and churches,
> And business buildings and domiciles.
> Crows to the heights forever fly
> Over this town in a magic sky:
> The air is like an enchanted crystal,
> That seems to hold and magnify.

These lines from the poem "Petersburg," appeared in another of Masters' fifty-three published works, *Illinois Poems* (1941), and I was reminded of this passage by the volunteer on duty in the Masters Home in Petersburg (a building which was placed on the National Register of Historic Places in July of 1976). The quaint little white frame dwelling was pretty well deserted, but the poet's presence lingered in the writing desk, books, and breakfast nook, all the clinging artifacts that make up the atmosphere of a home. Of course, Masters spent the bulk of his life in Chicago and New York—he was a successful lawyer and an even more successful author, seeing his *Spoon River Anthology* go through one profitable edition after another. But his real home was the "Spoon River" he located in his heart and imagination, a numinous place he returned to again and again in his numerous books of verse and prose, like *The New Spoon River* (1924) and *The Sangamon* (1942).

Perhaps because of his courtroom experience or because of his association with Clarence Darrow (that inveterate champion of the dispossessed and the down-and-out), Masters heard all the discordant notes of

47

small-town life in rural Mid-America in those palmy days just before the U.S. entered World War One. In "Petit, the Poet," for example, he dramatizes the frustrations and anxieties of the rural poet whose work strains for perfection while ignoring the everyday beauty that "roared in the pines." In the famous "Anne Rutledge," he celebrates the enigmatic woman who became the source of Lincoln's mature sense of charity and humanity. She remains "Wedded to him, not through union / But through separation." My personal favorite is "Amanda Barker," the embittered wife who died in childbirth and blames her husband for all eternity:

> Henry got me with child,
> Knowing that I could not bring forth life
> Without losing my own.
> In my youth therefore I entered the portals of dust.
> Traveler, it is believed in the village where I lived
> That Henry loved me with a husband's love,
> But I proclaim from the dust
> That he slew me to gratify his hatred.

This is pretty strong stuff, especially for the poetry audience of 1915, accustomed as it was to the syrupy productions of the Genteel Tradition. Masters had a considerable amount of vinegar in his constitution, it seems, and much of his bitterness was directed at Abraham Lincoln, a man he hated (according to the spokesperson at the Masters Home) because Lincoln had crippled the South (which Masters loved) and because Lincoln had supposedly cheated one of the Masters clan in some now long-forgotten legal transaction. Although he wrote flattering works about Walt Whitman, Mark Twain, Vachel Lindsay, and Robert E. Lee, Masters attacked Lincoln's personality and competence in his 1931 drama *Lincoln, The Man.* My own theory is that Masters felt he needed a larger cultural space, or more psychological "breathing room." In his own mind, there just may not have been enough space in Central Illinois to accomodate him and Old Abe comfortably. So he solved this dilemma by savaging Lincoln, thereby exorcising the ghost of his presence.

After chatting and lingering around the Masters home, I decided to see as much of the Spoon River itself as possible (even though the Sangamon, too, served as Masters' inspiration), so I sought the fair hamlet of Bernadotte, which was available by "just following the road." What I wasn't told, of course, was that the road would be over sixty miles long and that the last leg would take me along a wonderful unnumbered back road that changed direction four times.

Crossing the Illinois River at Havana, I struck out in the direction of Dickson Mounds, that ancient Indian burial ground that is now the site of

a splendid and largely ignored museum. In the wetlands near the confluence of the Spoon and Illinois Rivers, I followed a muddy lane through the cottonwoods and willows, stopping to meditate on the blue-gray haze gathering over the marshes. Cattails and reeds waved in the brisk wind whistling from the northwest, and the blue haze gathered into a palpable wall on the horizon line. Great blue herons rose briefly from their resting places on a sand bar and flapped their giant wings awkwardly before settling down again in their protective cover of grasses and reeds. In silhouette, their pointed bills and peaked wings resembled the delicate brush-strokes of Oriental calligraphy. If I had seen this moment in a Japanese film, I would have oohed and aahed over its transcendent beauty. As it was, I had experienced an ordinary moment in Spoon River Country, the kind of free poetry that must have been beautifully abundant in Masters' boyhood and early manhood, before the strip-mines and power-lines had left their ugly marks on the landscape of Illinois.

In the gathering twilight outside of Lewistown, the clouds darkened like blue-black ink and slapped the windshield with a few angry drops before coming to a mysterious and abrupt halt. The clouds pressed down on the horizon, leaving a tiny crack through which the remaining sunlight, like light leaking under a bedroom door, flowed across the landscape in discernible streams, great bands of brilliance that illuminated the corn stubble and the hayfields, transforming the unpainted and weathered barns into white, stony-looking structures. The road rose and dipped through two lovely little valleys, with their occasional basswoods and evidences of rural art like the old steel plows transformed into mail-box holders and painted in patriotic tones of red, white, and blue. Apples and pumpkins and freshly-cut firewood were piled in the green yards around the farm houses, and fat cattle grazed placidly on the gently sloping hillsides.

After negotiating a complicated turn, I found myself in the tiny village of Bernadotte, which had clearly suffered from the recent flooding. Bernadotte consisted of a few dozen houses and a little cafe, most of the structures perched on the hillside, but a few were sandwiched between the main street and the Spoon River which breaks here over the slightest suggestion of a dam, causing a marvelous display of boiling and frothing white water. At the edge of the village a few old abandoned vehicles lay on their sides in the muddy fields like recently beached whales. Cars and trucks of tourists and visitors were greedily availing themselves of fresh home-grown popcorn, elephant ears, funnel cakes, candied apples, and other delicacies hawked by roadside vendors. In the little park near the river, an old-fashioned fish fry was in progress, offering (in my opinion) the chief culinary delight of the Scenic Drive. All day long I had been wondering about the survival of those rural voices that Masters loved so

The Essence of Allerton

At the turn of the century, when Robert Allerton was a young man in his twenties, people in Monticello and rural Piatt County considered him aloof and unfriendly, a loner. Most of them probably didn't know that he was virtually deaf from a bout of scarlet fever contracted in early childhood. Moreover, they certainly didn't know that he had just returned to Illinois after five years of intensive study at the finest art schools of Paris, Munich, and London—and that he was busily completing the Georgian mansion that we know today as Allerton House.

The very first Allerton, Isaac by name, arrived on the Mayflower; his great-grandson, Samuel W. Allerton, moved to Illinois, made a fortune in hogs and farmland, and helped to organize the First National Bank of Chicago. The Chicago newspapers routinely referred to him as a "cattle king." When his son Robert was born in 1873, Samuel gave him over 1,500 acres of farmland in Piatt County. In 1946 this legacy became the Robert Allerton Park that thousands of visitors enjoy every year.

Allerton Park now consists of 1,500 acres of woodland property, 250 adjoining acres designated for use as the Illinois 4-H Memorial Camp, and nearly 4,000 acres of productive farmland. The Park is under the management of the University of Illinois, which uses Allerton House as a conference center and maintains the grounds and buildings. The southernmost 1,000 acres of Allerton Park were designated as a National Natural Landmark in 1971. All in all, the estate contains over 1,000 species of plants and over 150 different kinds of birds and mammals—not to mention the fabled swamp rattlers that hikers occasionally stumble upon.

These statistics, however, fail to suggest the walk-around aesthetic experience that is the essence of Allerton Park. For Robert Allerton came to central Illinois at a time when he felt despondent and insecure, having decided that he could never rise to the status of a first-rate painter. His aesthetic yearnings were too strong to repress, however, and Robert Allerton became a great landscape artist. He roamed the world, especially

Europe and the Far East, collecting works of art and soaking up the design patterns of famous formal gardens.

The result is Allerton Park, a unique blend of river bottoms, forest, prairie, formal gardens, pathways, and over three dozen free-standing sculptures, including the famous Sun Singer, which, by itself, would easily justify a visit to the grounds. In early spring the forest floor is carpeted with violets and wild iris; warblers chirrup everywhere. In late spring the bottomland can flood sufficiently to blot out any sign of trails and pathways, as this tenderfoot discovered about five years ago. The hard-woods (especially the oak and hickory) provide brilliant displays of fall foliage, and the winter snows re-define the pathways that thread through the woods, criss-cross the gardens, and circle around the ubiquitous statuary.

Perhaps the most enchanting, and in some ways the most typical, spot in the park is the Garden of the Fu Dogs, a long wooded alleyway, flanked on either side by parallel rows of ceramic Fu Dogs that sport glossy blue-black bodies and porcelain white fangs. The dogs are not really dogs at all but stylized lions commonly used on the domestic altars of Chinese Buddhist homes in the nineteenth century. These particular Fu Dogs are oversized and sit squarely atop their own pedestals. I have watched the sun set from under the protective shadow of these Fu Dogs, and I swear the experience taught me more about Zen than the small library of books I keep on the subject. At the entrance to the garden stands the House of the Gold Buddhas, a Cambodian-styled tower that does, in fact, house two gold-colored Buddhas. Near the other end of the garden is a goldfish pond, stocked with immense goldfish that resemble large red leaves. It is altogether appropriate to point out that these fish originated in Imperial China and that the ancient Chinese likened the catching of fish to those rare moments of inspiration or great spiritual insight.

Unfortunately, some of the park's more rowdy visitors were insensi-tive to these Buddhist vibrations and respond to the garden by savaging the priceless ceramic pieces. Don Frith, of the University of Illinois art department, has done a splendid job of restoring six of the dogs, but the ravages of Illinois winters seem to weaken all of these old statues. Perhaps they just weren't meant for Illinois, but I intend to savor their sweetness, brief and fleeting though it may be. That passing beauty is what poetry is all about, anyhow.

If we continue along the trail leading from the goldfish pond, we arrive at the first of three somewhat bizarre statues in the park: Gorilla Carrying Off a Woman (executed by Emmanuel Fremiet in 1887). About a half-mile further on, we behold Fremiet's Trapper of Bear Cubs (1885). These hulking bronze pieces, while subtle in execution, do not seem to address our finest impulses. The gorilla has just captured a human female

and is hauling her off for purposes unknown, a kind of grotesque foreshadowing of King Kong. A feminist might see in this statue proof positive of her most cynical suspicions about the male animal. A macho-type, on the other hand, might view it as a representation of his most vivid fantasies. Let us just say that I was personally hard put to explain this statue to my five-and-a-half-year-old daughter. Then there's the matter of the Indian in the Trapper of Bear Cubs, a brave who is suffering an excruci-ating bronze embrace from a mother bear, enraged at the sight of her freshly killed cub that is hanging from the Indian's belt. Lastly, there is The Death of the Last Centaur, completed in 1914 by Antoine Bordelle, one of Rodin's students (there's a copy of Rodin's Adam in the Formal Gardens). While less sensational than the previous two statues, the Centaur strikes a particularly sad, almost discordant, note as it represents the death of the old pagan order and the gods of vegetation.

The most famous statue in Allerton Park, and the one that draws the most visitors, is undoubtedly The Sun Singer, cast in 1926 by Carl Milles as a memorial to the Swedish poet Esaias Tegner. It was Tegner who composed the "Song to the Sun," which inspired Milles in the first place. Sadly, most visitors are unaware of the words that belong with the magnificent statue. It stands sixteen feet high and is placed on its own pedestal in the center of a giant circular clearing about an eighth of a mile wide. The whole effect might be called "Hollywood wraparound": it is grand on an Egyptian or Napoleonic scale. The Sun Singer actually seems to cradle the glowing orb of the sun in his outstretched metallic arms. The experience was captured long ago by Tegner:

> I will sing unto thee,
> O thou radiant sun,
> High aloft on thy throne
> In the deep, azure night
> With the worlds left and
> right
> As thy vassals.

On a less cosmic scale, and decidedly closer to Mother Earth, stands Allerton House, a Georgian-styled mansion, surrounded by gravelled walkways and reflected magnificently in the adjacent spring-fed pond. The house was basically completed by 1899, and Allerton originally called this splendid two-story brick and stone edifice "The Farms," as if it were some prairie cabin thrown together with logs and branches. The house was the result of careful study of similar dwellings in France and England, conducted on a long trip Allerton took with fellow art student Joseph Borie who actually drew the final plans. There are two other houses on the estate: the Gate House, a kind of miniature of the main house, and the

House in the Woods, an elegant cottage that boasts, as lawn ornaments, two old English lead garden figures. The one of the young girl with her billowing petticoats and smartly brimmed hat is especially charming. I always linger over it on my way to the Sun Singer.

Of course, many visitors come to the park for recreation of a less rarefied kind: tossing Frisbees or flying gaudy kites in the giant meadow next to the formal gardens, holding hands on romantic ramblings around the perimeter of the park, sniffing flowers, or even getting married. There are some 150 to 200 weddings per year in Allerton Park, the most favorite setting being the Sunken Garden, although, according to park ranger Dave Bowman, people have been married all over the park in all four seasons. All year long various groups use the main house for conferences, meetings, lectures, seminars, and the like. Many participants spend the night in the neat guest rooms located just north of the house. Allerton Park is open every day of the year, from ten in the morning until the sun finally sets in the arms of the Sun Singer.

In 1937, nine years before he gave the grounds to the University of Illinois, Robert Allerton purchased a tropical estate in Lawai-Kai, Hawaii. For the rest of his life, he and John Gregg, his life-long friend and associate, worked on that estate in much the same way that they had worked on Allerton Park. The small tropical paradise he reserved for his own private enjoyment; the larger, temperate one was meant for the public to enjoy. Our popular mythology is filled with stories of rich people who don't know how to gain happiness with their vast wealth—consider, for example, Howard Hughes or the mythical Charles Foster Kane in *Citizen Kane*. Robert Allerton didn't belong to that crowd, even though he was a millionaire many times over. All his life he heeded his father's words on the subject of money, expressed in a letter dated 1878: "Money is a necessity and a great blessing when properly used..." For an artist who just happened to be a millionaire, the "proper" use of money was to turn one's world into an art gallery and then share it with posterity.

Now about those rattlesnakes. Rumors and stories have attached themselves to the mystery of Allerton's life, tales inspired, no doubt, by his wealth, his taste in art, and his sheer presence in a landscape that could have been designed by Grant Wood of American Gothic fame. Many people insisted that Allerton imported the rattlers to keep out uninvited guests—and Allerton apparently encouraged this particular belief. Actually, the old swamp rattler or Eastern Massasauga (*Sistrurus catenatus catenatus*) was common in the northern four-fifths of Illinois but has virtually disappeared because of extensive agriculture. The swamp rattler, alas, is a native, one who generally prefers to be left alone.

I once saw three blue-haired grandmothers petrified on a narrow trail leading to the Centaur. On closer inspection, I discovered the old

massasauga curled up defensively on a bed of leaves. I gave him an undignified poke with a long branch, he proceeded to rattle angrily for about half a minute, and then he noiselessly disappeared into the forest. I do hope the Sun Singer was listening.

Cat Tales

My father, who is somewhat hard of hearing, began calling her Panther, a much more appropriate name than her real one, Panda. He encountered her during a Christmas visit when Panda, still a strutting kitten, was attractively fluffed out in black and white fur. She seemed an ideal complement to the Yuletide, a warm and cuddly presence, ready to lick any outstretched hand with a raspy little tongue the color of strawberry ice cream. With a red satin bow tied around her neck, she embodied feline cuteness, the primary quality we breed into domestic cats. Only two weeks earlier, however, Panda had required two extension ladders and a crew of six to retrieve her from the crown of a seventy-foot maple tree where she had spent the night in freezing temperatures. That night in the big maple was certainly not her first arboreal adventure. She had previously fallen twice from a large mulberry tree in our back yard, each time landing neatly on a pile of freshly raked leaves.

By my count, Panda had used three of her proverbial nine lives, but she must have consumed the remainder when she was savaged by the radiator fan of a neighbor's car. Somehow, she made it home, her tail hanging by a horrible bloody thread, ugly lacerations marking her flank and ears, one eye winking painfully. "Sometimes people bring in the pieces," the vet said nonchalantly. "We just sew 'em back together—happens all the time. Of course, her tail will have to go." Panda sat in a little wire cage, moaning.

She emerged a few days later with both eyes in working condition, absurdly wagging the short nubby stump of her tail. I thought I might pass her off as a Manx, that naturally tailless breed. "Did you know this animal is pregnant?" asked the vet in a tone of moral indignation. I suddenly felt like the father of a violated teenage daughter. My emotions boiled. I vividly recalled those good-for-nothing tomcats lounging on the premises. I had developed special dislike for two of them: a black wire-haired demon I called Fuller Brush, and a huge yellow giant I dubbed Felix Giganticus. Could one of them have fathered this unwanted litter?

I blame the ancient Egyptians for this mess. About 5,000 years ago they domesticated the wild African cat (*Felis Lybica*), hoping to develop a species of "watch cat" to guard their grain stores. The domesticated cat became so popular, however, that the Egyptians elevated it to the status of a divinity. Tombs frequently contained statues of Bastet, the cat goddess, and mummified cats were often included in the grave treasures of the deceased. The Field Museum in Chicago has a fine collection of these cat mummies, odd and spooky beings who have survived for thousands of years in brown linen wrappings.

Cats somehow appeal to our deepest spiritual and erotic leanings. Consider the role of black cats in magic and superstition—and their ubiquitous presence on Halloween. A quick review of everyday language ("catty," "cattin' around," "cat house") suggests that we think and feel in the language of the cat. How many cheap romantic novels, the kind with suggestive covers prominently displayed at supermarket checkout lanes, offer us heroines who "purr" and "arch their backs" at the slightest provocation? At this very moment, Stephen King's *Cat's Eyes,* a movie starring a cat with preternatural powers, is being screened at virtually every shopping mall in America. Some of us can remember earlier days when we knelt in the cool dirt and shot the Cat's Eye marble out of the ring. Those shiny glass globes were craved by everyone. For years I carried one in the pocket of my jeans, touching it from time to time like a secret totem.

Icons of cats so dominate the art of popular culture that we take them for granted. Everyone recognizes the original Morris, feline salesman of Nine Lives cat food, and his famous tag line: "Today I was not finicky." Ronald Searle made a tidy profit from his classic *Searle's Cats* (1967), featuring humorous drawings of cats with captions like "Two cats discover that love is a many-splendoured thing." The best example of this genre is B. Kliban's, *Cat* (1976), a collection of zany cartoons including the Red Chinese cat who says "Mao" instead of "meow" and the nitty-gritty folk-singing cat sitting on an apple crate. He holds his guitar in his paws and sings this earthy little ballad:

> Love to eat them mousies
> Mousies what I love to eat
> Bite they little heads off...
> Nibble on they tiny feet.

Kliban went on to make a fortune in pillows, coffee mugs, and T-shirts—all imprinted with the Kliban Cat. The market for such products seems inexhaustible.

Famous writers like Doris Lessing (*Particularly Cats,* 1971) have written about cats, but none so wittily as T. S. Eliot, who produced a little masterpiece called *Old Possum's Book of Practical Cats* (1939). A recent

edition (1982) features the marvelous drawings of Edward Gorey. Eliot's book became the basis for *Cats,* one of the most successful musicals of the 80s. Members of the cast are disguised as cats, and they sing inventive arrangements of Eliot's poems, my favorite being "Macavity: The Mystery Cat," a fanciful depiction of a sort of feline arch-criminal (like Sherlock Holmes' nemesis, Moriarty):

> Macavity, Macavity,
> there's no one like Macavity,
> For he's a fiend in feline
> shape,
> A monster of depravity.
> You may meet him in a
> by-street, you may see him
> in the square—
> But when a crime's
> discovered, then Macavity's
> not there!

After highly successful runs in London and New York, *Cats* is currently playing at the Shubert Theater in Chicago.

In this world of commercial exploitation of cats, the single most successful practitioner remains Jim Davis, whose Garfield loves lasagna and Jon's (his master's) fern. Garfield's saucy impertinence, presented in daily cartoon panels, must remind readers of their own uppity cats because Garfield's face decorates everything from cereal bowls to pencils—and consumers snap them up. In fact we could accurately describe the whole process as an expression of Garfield, Inc.

Fortunately, Panda is comfortably removed from the world of cats and high finance. She's stretched out languidly in the afternoon sun, waiting to be petted. Her stomach is distended in the fullness of her pregnancy. For days she's been waddling around, barely able to walk, eating voraciously—but still no kittens. I'm not sure how I'll deal with her offspring: certainly Illinois doesn't need additions to its present 5.5 million cat population. Richard Warner, a wildlife ecologist and professor at the University of Illinois, estimates that the cat population in Illinois will reach 10 to 15 million by the year 2000. Cats are predators, and in rural areas they can multiply rapidly, having a dramatic impact on wildlife, especially birds and rabbits. I don't want Panda's kittens to become part of this scenario, so I am sneaking this classified advertisement past my editor's watchful eye: ADORABLE KITTENS. AVAILABLE VERY SOON. FREE TO ANY GOOD HOME. 217/756-3285.

Flowers as Art Objects

When I moved to my old farm house in rural Shelby County, I vowed to plant a hybrid tea rose every spring as a way of marking the passage of time. That was seven years ago, and a quick inspection of my rose garden today reminds me that only four plants remain. An orange-hued Forty-Niner and a brilliant yellow Lowell Thomas fell victim to especially harsh winter weather, and last spring I fell victim to a massive attack of sloth. Roses, after all, mean hard work, more so than most flowers. They require a considerable amount of pruning, fertilizing, and mulching during their long growing season. On some of the hottest summer days I find myself down on my knees, as if in adoration, ministering to my rose bushes with peat, straw, manure, wood chips, and endless buckets of water. In return, the roses produce an outdoor art show that delights the eye and nose with dozens of beautiful variations on the theme of How to Be a Rose. Although I admire the Tiffany, the Peace, and the Carousel, I am most fond of my Mirandy, the oldest and hardiest of my survivors. Each year it produces large, cabbagey blossoms of a dark burgundy color with a subtle bouquet that is seductively sweet but never cloying. I take special delight in the buds, which go into a special silver bud vase not much larger than an old-fashioned fountain pen. I savor the tiny burgundy flowers like sips of my favorite wines. In fact, flowers and wine are the natural accompaniments of our most civilized and elegant moments. We use the word *bouquet* to describe both, and without wine and flowers human life would lose much of its sustaining joy and color. *Homo sapiens* positively needs a little intoxication from time to time.

Our much-maligned predecessor on the evolutionary scale, *Homo Neanderthal,* is known to have buried the dead in a ritual that included a circle of stones and flowers. So using flowers to express our finest feelings is a habit rather deeply embedded in human consciousness. It is hard to imagine a wedding, a funeral, a reception, or (more importantly) a comfortable room without the presence of flowers. The nearly forgotten Flower Children of the 60's were certainly not the first members of our

species to deck themselves with blossoms. Flowers or images of flowers are an inescapable part of human history. The ancient Egyptians modelled the first columns on the shape of the papyrus stalk and blossom. The later Greek and Roman columns were derived from the Egyptian ones, so all the columns on our official government buildings and post offices are nothing but glorified flower stalks! The ancient Romans honored Flora as a goddess of fertility and flowers. Of course, *Flora, Rose, Iris,* and *Lily* became human names, too. *Narcissus* is a very special instance of flower-naming since it suggests (all at once) the hero of a Greek myth, our unfortunate human tendency toward self-absorption, and the lovely cup-shaped flowers that are blooming in my back yard even as I write this article.

The ancient Persians and Syrians cooked with flowers and used them medicinally as well. The Syrians were particularly fond of the autumn crocus because of the saffron produced in the plant's interior. This yellowish dye found its way to England, where self-indulgent old Henry the Eighth forbade the use of saffron as food or hair dye; he hoarded the kingdom's saffron and used it as a condiment on his favorite foods. Even today the Pima Indians in Arizona eat the flowers of the cholla cactus, and residents of Central Illinois have been known to toss squash and pumpkin blossoms into the pot, creating one of the unsung delicacies of the region.

I was certainly ignorant of this long floral tradition when I began growing flowers. For me, roses and gladiolus were a good source of pocket money since I grew up in New Orleans, a semi-tropical city with more elaborate cemeteries (and probably more religious holidays) than any other place in America. People always seemed to be visiting cemeteries with their floral tributes in hand. The gladiolus made an attractive and long-lasting bouquet, and I believe I grew just about every variety at one time or another, including such Burpee classics as Cherry Surprise, Yellow Crown, Powder Blue, Peppermint Swirl, and Lemon Lime. New Orleans spoiled me in that I always took the abundance of flowers (especially azaleas, wisteria, dogwood, magnolia, and night-blooming jasmine) for granted. In New Orleans, spring happens all at once; by late February or mid-March the city ignites with color, and all the major avenues and boulevards are instantly transformed into floral trails.

If nothing else, my first winter in Illinois taught me that the world does not always express itself in semi-tropical colors but can just as easily reduce itself to snowy abstractions of white and gray. Yet when the snow melts, a slow-motion choreography begins, a dance of spring marked by the weekly appearance of new shoots and buds. Every step is clear and distinct. Tiny snow drops bloom in leaf piles gathered at the base of hardwoods. The first crocus appears in a freshly thawed flower bed, then the first daffodils and tulips. Soon the woodlands will begin to sprout with

May apple, Dutchman's breeches, and jack-in-the-pulpit. This year the wild plants and, indeed, all the flowering shrubs and trees have collaborated in a memorable explosion of color, the loveliest I can recall in my fourteen years in Illinois. A weather pattern of temperate (even warmish) days and cool evenings has allowed blossoms to appear and remain in place so that crab apple, forsythia, redbud, and hawthorn are truly resplendent. Some years they seem to bloom and disappear overnight. The lilacs are especially abundant and fragrant, hanging like bunches of white and purple grapes.

Lilacs deserve special mention because they seem to belong to Illinois, at least if you believe in the poet Walt Whitman, who wrote his best poem on Lincoln by focusing on the lilacs blooming in the month of April. Lilacs were blooming in April of 1865, also, when Lincoln was assassinated and put on board the long black funeral train that made its way slowly and deliberately back to Springfield. In his grand elegy, "When Lilacs Last in Dooryard Bloom'd," Whitman places his sprig of lilac with "heart-shaped leaves" on Lincoln's coffin and dedicates all future lilac blossoms to the memory of the slain president. In Whitman's poem, the memory of Lincoln is re-awakened every spring with the appearance of the flower. If Old Abe's ghost is around this spring, he must feel wholly gratified: the lilacs have put forth their best display, a worthy gift for the state's most famous citizen.

Flowers aren't for presidents and historical figures only, and one doesn't need a sophisticated cultural background to appreciate them. Flowers are everyday art objects, the closest and most obvious experience with beauty that most people have. Names and associations of flowers are less important than the mental snapshots we take of them, the instantaneous pictures we carry consciously or unconsciously for the rest of the day. I, for one, never forget the marigolds planted around the flag pole or the geraniums in the flower box. We learn to appreciate flowers even before we can speak—just watch little children playing with flowers and presenting them as love-offerings. Flowers are the language that precedes language, a dialect of color and beauty that everyone instinctively comprehends. I love my little plot of cosmos, wafer-thin, orange-red flowers that seem like spots of color as they wave against the white background of my house. The cosmos is delicate with petals as thin and slippery as silk, more like a watercolor of a flower than a flower itself. Last year I grew them everywhere, especially in my vegetable garden, where I made late summer harvests that satisfied the appetites of mind and stomach simultaneously.

Some years ago I was buying seed potatoes from a man who sells garden supplies in a shed by the highway. I noticed an unmarked box with a few dirty tubers lying in it. "What are those?" I inquired, assuming I was handling something potentially edible. "Cannas," he muttered in reply,

"you know, cemetery plants." From that single tuber I grew (in the space of two short years) over three dozen tall, leafy plants (the tallest was slightly over six feet) that produced lovely crimson blossoms which remind me of gladiolus on a giant scale.

The red flowers are admired by hummingbirds, not the fancy ruby-throated variety but the little brown ones that frequently appear in rural Illinois. One of them visited my cannas every afternoon for a week, while I was sitting under my apple tree, reading a novel and trying to find relief from the overpowering heat. The little bird just hummed along in temperatures over 100 degrees. That kind of persistence with flowers isn't unusual in the animal kingdom. I've seen blue jays and cardinals land on my giant sunflowers, attach themselves to the edge of the flower like a C-clamp, bend over, and in a clearly uncomfortable, upside-down position, peck away at the ripening sunflower seeds until completely satisfied. When they clumsily attempt a take-off, they look more like little seed bags with wings than bona-fide birds.

I also treasure my hollyhocks and their pink and white blooms, in spite of their spindly stalks that often need propping up or binding together before the season is completely over. These hollyhocks persist, however, and each year I find more and more of them growing along the fence that borders my half-acre yard. I also cherish a gift of wild iris, dug up on the farm of a friend of mine. The irises are co-existing happily with my cosmos, and their violet, orchid like complexity is a beautiful complement to the burning orange color of the simple cosmos. At one time or another I have given or received violets, caladiums, daylilies, roses, geraniums, lilacs, and several varieties of cacti. Like all the human generations before us, we were "saying it with flowers." As I walk around the rooms of my house, I see cut flowers left by various members of the family: lilacs in a big glass vase, a tiny grape hyacinth in a blue vase, an apple blossom in a white ceramic vase. I regret the loss of that apple blossom, but I see my wife has put it to good use as a model for a watercolor she has just completed. She will probably sell that picture eventually—or give it to a friend. Either way, that single flower, like most of its peers, will have gone through several cycles of appreciation.

Of course, poets and painters have relied on flowers as subject matter for over 5,000 years. The Japanese and Chinese developed elaborate techniques for painting and arranging flowers. Oriental art would be unthinkable without depictions of chrysanthemums and plum blossoms. The Chinese began the practice of painting flowers on porcelain plates and saucers, and some of the first Oriental exports (before the Age of Toyota) were special sets of porcelain dishes, all painted with flower designs, and destined for far-away ports in England or Portugal. In the Western tradition, one of the most famous flower paintings is Botticelli's

La Primavera (Spring) in which Spring is imagined as a tall, blond woman who scatters flowers like a farmer broadcasting seed. Vincent VanGogh is justly famous for his still-life of a sunflower, and Claude Monet constructed a special water-garden at his home in Giverny, France just so he could grow the waterlilies he celebrated in his many paintings. Even the late Georgia O'Keefe painted strange and inscrutable flowers that might have come from the depths of her unconscious mind.

I do not mean to suggest that all of my experiences with flowers have been successful or pleasant. For many years I have struggled—unsuccessfully—to beat a jinx on my ability to grow celosia, those fuzzy, flame-shaped clumps of flowers that come in blazing red, yellow, and magenta colors. For some reason the lowly aster refuses to grow in the confines of my yard. And although I do not absolutely dislike any flowers, I certainly have my preferences. I can gaze all afternoon at tulips, especially the large red ones streaked with yellow and orange, or the tiny pink ones, but I cannot summon much enthusiasm for pansies, pinks (dianthus), or petunias—there is something repellent and tawdry about those blooms that I have never really accepted. These are my prejudices. There are even times when I don't particuarly feel like contemplating my flower garden at all.

When I become too sensitive to flowers, I seek a few moments of oblivion at a spot where Eagle Creek drains into Lake Shelbyville. On one recent evening I was walking along a particularly beautiful ridge of hardwoods (burr and pin oak), a network of black branches without a single green bud. Scattered in the midst of the oaks were wild and abundant redbuds, generously hung with purple and magenta flowers. The sun began setting across the broad, still surface of the water, and every few moments the pink and lavender tones expanded until Eagle Creek and the twisted line of redbuds united in a purple harmony I have no way of naming. I experienced one of those rare moments of human insight, and for a fleeting instant the old, fractured world became absolutely simple and familiar, like a flower held in my hand. The sun went down, the trees darkened, and the sky was rinsed in cold starlight. I knew that somewhere in the south lay Halley's comet, like a rare bouquet offered once in a lifetime.

Gardening for Body and Soul

When one of those arctic nightmares, like our recent Siberian Express, transforms the world into an icy impossibility, I seek out the warmest nook in my old farmhouse and engage in my favorite wintertime activity: fantasizing about my spring garden. I come to the task well prepared with a stack of seed catalogues, the results of previous orders for the perfect tomato (like the Gurney Girl), the glossiest zucchini (Burpee Hybrid), or the sweetest sweet corn (Field's Tendertreat). Over the years I suppose I've tried them all. Given a category of fruit, flower, or vegetable, my mind spills out data like the file of a small personal computer. Under beets, for example, I readily list Detroit Red, Early Wonder, and Ruby Queen. Under carrots I count Chantenay, Danvers, Imperator, and Oxheart. I haven't the heart to plant seeds anonymously: I want to know the name of what I'm putting in the ground.

Gardening is a year-round enterprise. When I'm not doing it, I'm dreaming about it, talking about it, watching weather maps and my trusty thermometers. No activity is quite as satisfying or rewarding. It is effective therapy for the tired mind, and, with a little luck, it generously rewards the blisters and sprains acquired in the rituals of tilling, planting, and weeding. A basket of ripe tomatoes, a bucket of fresh strawberries, or a bushel of roasting ears are edible proof that the world still works, at the most basic level of soil, sun, and moisture.

Gardening teaches patience, and more: it imparts a fine discrimination for every shading of green and every pattern of leaf, from the little elephant ears of the radish to the ratchety leaves of okra or the hairy, fern-like growths of asparagus. To put these fragile green things into the earth is to rediscover a whole encyclopedia of aches and pains, especially lower back pains and nasty blisters in the center of the palms. The hoe at this time of year can seem like civilization's cruelest instrument of torture. And yet ... the whole process stays with you in a way that is unique. Fishing and woodworking have their special pleasures and residues, too: you may smell sawdust or fish scales for days afterwards. But gardening requires the

ingestion and absorption (if only by osmosis) of a considerable amount of soil. Good garden soil should adhere to the gardener, inhabiting intimate spaces under the fingernails and permanently discoloring the knees of every pair of jeans drafted into garden duty. On even the coldest day of winter I can still smell the rich, warm humus I have lovingly cultivated as my own.

I enjoy gardening too much to take it too seriously. I'd describe myself as post-hippie, middle-class organic gardener. I won't abide any poison in my garden, but I won't read every new book on "French Intensive" gardening or go to ridiculous extremes in the pursuit of a weed-free environment. Several years ago I discovered that weeds were inevitable and that a certain population of them could be comfortably tolerated by me—and by the plants. I know that every year stem-borers will destroy some of my summer squash and that little pests will attack my potatoes and string beans. Usually, I compensate by planting early and by overplanting. I give my tithe to the Church of the Insect Kingdom, and the contribution is always cheerfully received.

A potter friend of mine derives great pleasure from giving the products of his craftsmanship to friends. A piece of art, like the mug he made for me with his signature on the bottom, becomes a special kind of binding gift between the ceramic artist and the recipient. I like to think of my garden produce as gifts, too—unsigned, perhaps, but truly works of art that sprang from the earth with my assistance and nurturing.

The garden has been a social device in other ways, too. Many people who would never discuss politics or religion with me have found that gardening is a safe and unusually productive topic. It can bring out the best in both parties. Other conversations are more directly related to the garden, as when one of my neighbors peers over the fence to inspect the progress of my cauliflower, adding that I might save that snowy white head from discoloration by pinning the leaves together with a clothespin. I tried this folk remedy, and it works.

The garden has worked its way into my life in other, more subtle ways. It isn't just a source of work, food, gifts for exchanging, or topics for conversation. It exists. And I have learned to share it with other living creatures, too. A rabbit has moved in, tolerated after two years, and impossible to dislodge once her bunnies appeared. Every now and then I'll pick a carrot with her distinct, toothy impressions. Once she ate an entire row of young sugar snap peas.

I grow a few giant sunflower plants, and these have become a gathering place for a family of blue jays, who nest each summer in an adjoining mulberry tree. During last summer's spate of one-hundred-degree days, I was visited on a daily basis by a green hummingbird who

sought a saving drop of sweetness from a canna plant I was growing in the corner of the garden.

Some of my best moments occur in mid-summer when the nights are still clear and Cassiopeia rises in the northeast. Under the roof of stars, I stand barefoot holding my green garden hose, lulled by the shushing sound of the spray, the gathering darkness at my feet, and the sprinkling of starlight overhead.

What doesn't get eaten or frozen is put up in pints or quarts that become the precious companions of fall and winter. More satisfying than even the glossy photos in the seed catalogue is the sight of a long row of pickles or preserves. They stand like works of art, each glass container enclosing an artifact of the previous summer. Like the fine wines, the contents of each jar preserve a unique blend of rain and sunlight that produced this particular expression of string beans, or cauliflower, or cucumber, or strawberries, or beets. Sometimes it's enough just to look at them, to save them for tasting on one of those deep-drifted days when the roads are closed and I moon over my catalogues....I see they're bringing out some new pear tomatoes this year, something called the New Ace Hybrid Sweet Pepper and, on this page, Kandy Korn Hybrid Corn. Now, let's see: the pear tomatoes can go over here, the peppers there, and the corn out near the fence, where the snowdrift is deep, and pure, and undisturbed.

Double-Think and the Fine Art of Gardening

My first garden, a paltry urban affair, consisted of three raggedy rows of beans hacked out of the stony turf in my back yard. The seeds had cost a dime and came in a glossy packet I bought at the local drugstore. Memories of the first Earth Day and of Hippies with garlands of flowers in their hair must have inspired me to plant. All of my friends at this time carried copies of the first Whole Earth Catalog in their little green knapsacks and quoted it like Scripture. I would spend my mornings attending a seminar on Thoreau's Walden, and I had come to admire the way he turned simple bean-growing into a transcendent human experience. I wanted a piece of that action, too.

Everyone I knew talked to their plants. In the heavy blue haze that typified the parties of that period, people would fix their granny glasses on you and explain the absolute necessity of "relating" to your plants. Affected by their hypnotic gazes, I took this talk seriously. There I was, on all the available sunny afternoons, sitting on my pathetic plot of ground, reading Yeats to my little bean sprouts. I always read the same poem, "The Lake Isle of Innisfree," because it seemed like the most appropriate text, especially these lines:

> I will arise and go now, and go to Innisfree
> And a small cabin build there,
> of clay and wattles made:
> Nine bean-rows will I have
> there, a hive for the honeybee,
> And live alone in the bee-loud glade.

At first, this word-magic worked powerfully. The sprouts became spindly plants and then coiled themselves into vines twisting up their poles. I charted their progress by making notches on the poles: one day they grew four inches. I began my seminar paper on Thoreau, and the vines exploded with hundreds of lavender bean blossoms. Soon the

67

miniature pods began to swell into fat green fingers, each "knuckle" containing a bean.

Then reality, in the form of Killer Caterpillars, attacked my beans savagely, destroying my poetic interlude forever, and eating my green beauties down to their tiny capillaries. Although I never tasted that crop, I have since savored it in my imagination. Every Blue Lake or Contender I harvest today is sweeter for the experience of that ghost-garden. That first disaster, and all the others that followed, instructed me in the fine art of double-think, teaching me that for every growth there is always the potential of no-growth. Gardening changes your image of things: you begin to see the world in photographs, and you know that every photograph surely has its negative.

Consider, then, this portrait of my winter melons. I first enjoyed this subtle Oriental squash in Chinatown (New York City), but I bought my winter melon seeds in Chinatown, Chicago. The seeds came in a small brown envelope covered with black brush-strokes of calligraphy. The proprietor of the small grocery story spoke only broken English, and he kept the seeds in a bin marked "winter melon." Perhaps I did not purchase melon seeds at all because what I got was hardy vines and mustard-yellow flowers—and more flowers, but no melons. My neighbor loved my "new flower bed." She "had never seen such lovely flowers," nor had I. They bloomed all summer long, and at some point I began to simply appreciate the flowers. I had not picked a single winter melon, but there had been a bountiful floral harvest, after all. I was reminded of the Japanese saying "Every haiku is like every flower—beautiful and lovely in itself." One side of me was acting like a hard-nosed gardener who loves the produce (strings of onions, bushels of potatoes, pints of cucumbers, quarts of tomatoes); the other side would just as soon grow a little poetry. The vagaries of Illinois weather on any given year virtually guaranteed that both sides of my confusing personality would be accommodated.

One year we experienced an Edenic mixture of slow, soaking rains, warm (not tropical) sunshine, and cool (not cold) nights. Entranced by the illustrations of zucchini, I had ordered several varieties, including Spanish Gray Zucchini, planted the seeds in straw-mulched mounds and watched the squash blossoms fade and disappear, leaving perfect little squash behind. They were almost ripe when the rain came to an abrupt halt and the temperature climbed to 104 degrees, where it remained for ten straight days. I tried sprinklers, hoses, and even carefully-poured buckets of water, all to no avail. In the end, the squash plants oxidized, even down to the vines, which looked like scorched rope discarded after some terrible conflagration. Only in my imagination do the Spanish Grays grow to perfect maturity, to be picked and sliced, sauteed, or (in my favorite fantasy) stir-fried with shrimp and bay scallops.

Fantasy and reality rarely coincide, however, and I should have remembered that maxim while day-dreaming over my Norway Maple. The advertisement promised that "only select stock will be shipped," and the photograph was grand. Do nurseries have special lacquers to dress up the apples and squash in their catalog pages? Do the photographers employ devious tinting or filtering to produce those perfectly proportioned trees? Isn't much of our gardening—perhaps the richest part—here in the day-dreaming over catalog pages?

My Norway Maple touched the heavens, a true totem of autumn, with the loveliest burgundy-colored leaves ever put on film. It arrived as a stick in a long paper carton, fastened together with heavy industrial-grade staples. A few hair-like roots sprouted from one end of the lifeless twig. I soaked it in a tub of water, dug my deep hole, added manure and humus— and a stick it remained. I asked the county agricultural adviser to examine it, and he pronounced it dormant. "That tree isn't dormant," I exclaimed, "it's sleeping the Big Sleep!"

Double-think has readied me for all the possibilities, even success. After last year's Siberian winter, my Mirandy tea-rose refused to send up shoots, even though it had been cut back to ground level and mulched over with a bale of hay. I mourned its loss because it had been my personal favorite, producing wine-red blossoms, some as big as the span of my hand. Its neighbors (a Peace rose and a Queen Elizabeth) had begun to bloom when the Mirandy belatedly sent up its stalks. By the end of the summer, it surpassed them in height and in the number of blossoms—not a bad output for a moribund plant. This week my asparagus (only faint green hairs last spring) came up as thick as my finger. You just never know what's going to happen, and I have this feeling that 1985 could be a vintage year, even for Spanish Gray Zucchini.

Of Typed Menus and Sweaty Cooks

They file into the Chili Parlor from all walks of life: hip young executives in three-piece suits and blow-dried haircuts, factory workers with bright yellow hardhats, mechanics with oval name patches embroidered over their breast pockets (Rick, Pee Wee, Lonnie). And they are all drawn by the heavenly scent of chili, bubbling in the stainless steel vats of the Chili Parlor in Decatur.

The stuff comes in four degrees of spiciness, the hottest being designated as Flamebowl. I once saw a petite secretary put down two bowls of this liquid napalm, smile like the proverbial Cheshire cat, and tiptoe demurely out the door. On the other hand, I have also seen grown men weep at the first spoonful of this incendiary preparation which frees the nostrils, opens the darkest recesses of the sinuses, and causes the ears to pop, not unlike the ear-popping sensation that comes with rapid changes in altitude. To eat the Flamebowl is to come to terms directly with the Dragon, that fire-breathing presence whose flaming tongue licks the back of one's neck until heat prickles rise and sweat droplets pour from the forehead.

I love the out-of-the-way places like this, with their House-That-Jack-Built architecture, their hand-painted signs, typed (never printed) menus, and waitresses in unmatched garments. How different from the plastic shacks and uniformed robots at those fastfood joints that offer "food" which has often been processed and frozen at some central plant, shipped in a refrigerated truck, and shot through a microwave oven, before being served to the customer in a little styrofoam coffin. I like to see real kitchens, sweaty cooks, and deep frying vats whose oil has the strength of industrial lubricants. These little restaurants, lunchrooms, cafes, and eating parlors may be the last vestiges of true Americana, walk-in museums where the artifacts can actually be eaten, which is the supreme form of possession, the final gesture of the careful consumer who compares, admires, buys, and ultimately swallows his purchase.

There are days when I don't give a hoot for the Surgeon General and all his puritanical pronouncements. These are the times when the urge for high-cholesterol, deep-fried foods becomes overpowering. If these urges come fortuitously on a Friday, I am drawn helplessly to Champaign's Deluxe Bar and Grill where the fried catfish sandwiches, kosher dills, and draft beer are victual just this side of heaven. What a pleasant way to start the afternoon: an amber mug of beer like distilled sunlight and a platter of fish sandwiches to share with friends! People used to imagine heaven as a place with golden streets where all the inhabitants went around strumming their celestial harps. Personally, I've imagined heaven in humbler terms, as a mouthwatering restaurant where lunch is always being served. I do hope someone is saving that corner booth for me.

Dinner is altogether another matter. Dinner is a lunar affair, which may explain my fondness for driving through the cornfields on autumn evenings, under the horns of a golden harvest moon, threading my way toward La Conca D'Oro (The Golden Gulf), an unobtrusive, Mom-and-Pop operation (yes, they're Italian) in Taylorville that provides home-made pasta and slowly simmered tomato sauces that create a happy detente among the pungent forces of basil, oregano, and thyme. The chicken cacciatore, basted in its own juices, arrives swimming in a shallow pond of tomato and rosemary gravy that, by itself, would justify the visit. Even now I can recreate its other-worldly aroma. But I like the down-to-earth dishes, too, like the tomato sauce with chunks of Italian sausage or even the oversized plate of homemade thin spaghetti covered with tomato and mushroom sauce and as much Parmesan cheese as I can decently spoon over the mixture. I suspect that Mom and Pop are cooking for the tastes of Midwestern farmers, which may explain their light touch with the garlic. Personally, I can never have enough.

Local cuisine need not be ethnic in origin, however. Basic American dishes like steak and potatoes can become memorable eating experiences if there is artistry and love in their preparation. I will readily admit that I am no big eater of steak, but I succumb to the temptation occasionally, especially if it takes the form of a buttery, velvety cut of beef, thick enough for the hungry tooth, pink but not bloody on the interior, and seared but not burnt on the outside. These criteria are more than adequately met by the large New York strip at Stoney's (of Dalton City), my favorite steak restaurant of the province. Regular customers drive from such places as Indianapolis and Chicago to savor this beef, accompanied by outstanding salads, and my favorite appetizer: fried zucchini sticks. I must also add that the Friday night catfish special would put to shame many a filet of Dover sole or trout almondine.

I began by describing the Dragon and his firey embrace, but I neglected to point out that the Dragon is really an Oriental creation, an

71

imperial motif found not only in the Forbidden City of Peking but on napkins, marquees, and matchbook covers of the thousands of "Chinese" eateries in the United States. Let's play a game: in Column A, imagine Chinese colors like red, green, golden, jade, etc. In Column B, imagine some distinctive Chinese locales, such as palace, pagoda, village. Now, start combining items from Column A with random selections in Column B, and you are well on your way to inventing a Chinese restaurant. The Golden Pagoda, perhaps, or maybe the Jade Palace. You can earn extra points by using imperial and dragon as often as decency permits. Add a plentiful supply of monosodium glutamate, paper lanterns, and dark-haired waitresses in red pantsuits, and you're ready to open.

If I satirize here, it is only because so many places pass for the real thing. It takes more than bean sprouts and a pot of green tea to make a Chinese restaurant, but since there are so many of them, a little patient searching can usually result in a gustatory delight. Among the three dozen Chinese restaurants in central Illinois, I cite Moy's in Champaign for consistency and value: the appetizers, especially the barbecued ribs, are sumptuous. And even though I might like a little more aged cabbage in the egg rolls, the wonton skins enclosing the egg rolls are pressed thin and perfectly fried so that they achieve the crisp airiness of French pastry. The egg drop soup satisfies without bloating the belly, and among entrees the beef "imperial" deserves special praise. Marinated chunks of beef are stir-fried with fresh snow peas and bean sprouts in a slightly pungent sauce, and the whole business is dumped handily on a bed of perfectly steamed (never boiled) rice. I usually finish this meal off with two pots of the freshly brewed jasmine tea.

I freely concede that the tamales aren't perfect at the Chili Parlor, that the Deluxe Bar and Grill is often noisy and overcrowded, and that the ravioli at La Conca D'Oro were, on one occasion, lumpy and uninviting. But what a delight to have such opportunities in our midst, good places to eat among so many others—need I mention the awesome pastry cart at the Lamplighter (Champaign), the double pork chops at the Hog Trough (Moweaqua), the pickled beets at the Dutch Kitchen (Arthur), or the shrimp with lobster sauce at the Yen Cheng (Champaign)? We write the book on these restaurants, filling the pages with the memorable meals we hope to eat again. This is everyday sport, and may I wish us all happy hunting and good eating!

The Second Wave: Indonesian, Japanese and Vietnamese Restaurants Invade the Heartland

By now most American consumers are all too familiar with the conventional dishes of Chinese-American cookery. We've all encountered predictable menus of egg rolls, fried rice, sweet and sour pork, egg drop soup, fortune cookies, and other safe offerings that—for most customers—are synonymous with Oriental cuisine. A few brave souls have ventured into the mysterious precincts of "Chinatowns" in big cities like New York, San Francisco, or Chicago, where one may sample Chinese hors d'oeuvres like little sausages, egg dishes, special pastries, and other toothsome goodies known collectively as *dim sum*. I once entered the Yun Luck restaurant in New York City after the conventional lunch hours and witnessed the staff eating all sorts of entrees from big bowls while they scooped out mounds of steamed rice from an even larger bowl placed strategically in the middle of the table. That afternoon introduced me to steamed sea bass with scallions (the beast arriving at my table with head and fins intact, and one glazed eye that stared at me philosophically during the entire meal). I later returned for a seafood combination dish (served on fried rice noodles about the size and consistency of ravioli) that featured abalone, squid, lobster, shrimp, and some strange convoluted creatures trawled from the bottom of the sea.

Of course, most of these exotic dishes were not readily available at the neighborhood Jade Garden, where patrons were pleased and satisfied to munch on cashew chicken, beef and snow peas, and other culinary cliches. Yet even that pattern began to change in the 1970's as Northern Chinese cooking began to appear in the form of Hunan and Szechuan establishments offering red-hot and spiced-up versions of some of the old favorites. Chili peppers, ginger, and garlic began to dominate much of the Oriental food served in the United States. It was during this period that profound social and economic changes (the end of the Vietnam War, the surge in Japanese imports) helped to usher in the Second Wave of Oriental restaurants. Of course, cultural changes are sometimes slow in

coming to the Heartland, but in the past *two months* no fewer than *three* new Oriental restaurants have opened their doors in Springfield. And suddenly the consumer is faced with a whole new range of possibilities when the "yen" for Oriental cooking becomes overpowering.

Probably the most successful of these new eateries is the Tokyo of Japan (517 South Fourth Street, 789-7744), where food is served in the *teppan-yaki* style: a high temperature grill is built right into the table top, and the chef individually prepares each meal with a theatrical routine that is certainly worth at least one visit. Patrons familiar with the Benihana restaurants of Chicago will instantly recognize this style of presentation. The Tokyo is housed in the former restaurant of the Mansion View Motel, and the walls and interior decor have been tastefully redecorated in the Japanese manner (grass mat walls, framed calligraphy, fountain, and stone sculpture). In order to accommodate the *teppan* grill, there is loss of table space, so seating is somewhat at a premium, and reservations (especially for dinner on weekends) are mandatory. An adjacent lounge accommodates the overflow and walk-in customers.

Service was fair at the Tokyo: our waitress had to be reminded *three* times to bring our tea, and glasses of water did not appear until the very end of the meal. She also seemed strangely uninformed about the contents of the entrees, although she was pleasant and friendly, offering us the traditional steamed hand-towel at the beginning of the meal and adding a touch of color with her bright blue Japanese costume. But the chef was clearly the star of the evening, showing up in a tall blue *toque* (puffy chef's hat), armed with a holster containing a sword-like knife, and all the while wheeling a little cart loaded down with all the raw ingredients and condiments to create our meals. The most popular item on the menu is the Dinner for Two (steak, chicken, and scallops, $28.00), but our party sampled the Hibachi Chicken ($7.95), Sukiyaki Steak ($9.95), and Seafood Combo ($17.75)—these prices included a complete dinner of onion soup (rather ordinary but palatable), a green salad with a lively mustardy-tasting dressing, shrimp appetizers (prepared on the grill), and vegetables (zucchini slivers, onion slices, mushroom slices, and bean sprouts—all prepared on the grill). I should emphasize the very high quality and freshness of all the raw ingredients: the vegetables, shrimp, chicken, steak (sliced thin and scrupulously free of fat), scallops, and lobster tail (arriving with its protective shell). It's nice to see what's going into your meal, and it's even nicer to have the preparation of that meal transformed into theater.

Our chef was a born showman, jocular, gregarious, and high-spirited. He called me Papa-San; he made jokes about how scared he was to cut himself while he sliced through the shrimp with lightning speed and then frowned menacingly like a samurai warrior as he proceeded to chop

off the tails of his tiny, crustacean adversaries. He had begun with a ritual scraping, cleaning, and oiling of the grill, firing it up to maximum temperature so that all the ingredients would be seared on the outside with their succulent juices preserved within. The aroma of all the different foods at the Tokyo is heavenly, and half the fun is *smelling* all the dishes before they are actually ingested.

At several key junctures during the preparation of our food, the chef performed an incredible warrior ballet, looking like a *ninja* assassin as he wielded the oversized salt and pepper shakers as if they were clubs, knocking them together furiously so that they cracked like castanets. He also performed *teppan* magic with his spatula which he turned sidewise as a chopping and slicing implement or shovelled upward, expertly flipping bits of shrimp and beef onto the large white plates that were parked on the edge of the grill. I found all the entrees excellent, but I especially enjoyed the steak (medium rare and overflowing with tasty juiciness) and the lobster (tender-crisp, with just enough soy sauce and black pepper to give it zip). The rice and green tea were undistinguished but certainly accept-able. Since I was already approaching the perilous edges of discomfort and satiety, I did not sample the desserts (ice cream, sherbet, and melon). Coffee was also available, but the beverages most in evidence were the pricey ($2.50 to $4.75) mixed drinks with names like Karate, Geisha, Samurai, and Buddah.

Last summer I ate at the Shiro Hana (Philadelphia), reputed to be one of the finest Japanese restaurants on the East Coast. The style there is severe and temple-like: one is served on a mathematically designed tray with minute compartments for items like *sushi* and various pickled vegetables and seaweed. A tiny flagon of warm (not hot) *sake* accompanies the meal (a beverage I sorely missed at the Tokyo). I have also sampled Japanese home-cooking through the rare accident of having a Japanese sister-in-law (who hails from Kyoto and runs a small Japanese restaurant in New Orleans). But the Tokyo is clearly not trying to present the most Japanese of Japanese foods—I would describe the food here as first-rate stir-fry cookery, although F., my Oriental "Deep Throat" in Springfield, considers the food half-American, half-Japanese. I might add that it is still 100% satisfying, no matter how one analyzes its place in the culinary scheme of things. When our meal was finished, we were rushed out rather brusquely (like Toyotas on the assembly line) to make room for the customers already lining up. In all fairness, however, we had no reserva-tion, and the hostess did apologize for the awkwardness of the situation. Again, let me stress the importance of making a reservation at the Tokyo, especially on weekends. The food and the theatrical presentation are more than worth that little bit of advanced planning.

By comparison, the atmosphere at the Bali Island (2929 South Sixth across from Fiat-Allis in the Abe Lincoln Motel, 523-6060) was rather sleepy on the week night that I visited, but the owners (Rocky Chan and Lestari Chan) have a considerable amount of restaurant expertise behind them, having previously operated Oriental restaurants in Taylorville (the Teac) and in Peoria (the Haylu-Moon). Rocky is a refugee from mainland China who corresponded with Lestari after he came to America and while she was still living in Indonesia. They met—and were engaged—in Hong Kong, so they bring a rich, multi-cultural perspective to their work and marriage. Rocky speaks little English, and Lestari does so haltingly, but she is one of the most gracious hostesses I have ever encountered. Indeed, I felt as if I were eating in her own home. The interior of the restaurant was neat and spotless. Indonesian food was a new gastronomic experience for me, although I had tried Thai and Vietnamese food, which are often compared to Indonesian cuisine. I began the meal with *soto ayam,* a lovely chicken broth with shredded chicken, green onions, bean sprouts, and shredded cabbage. This soup was followed by the only recognizable item on the menu—an egg roll, stuffed mainly with cabbage and fried with a light touch. I then tackled my *gado-gado,* a delightful and unique salad (bean sprouts, lettuce, tomato wedges, and shrimp chips) laced with a slightly pungent and exquisitely tasty peanut sauce or dressing. A trip to the Bali would be justified on the basis of this peanut dressing alone; I have never tasted anything exactly like it. Somehow that peanut flavor enhanced and harmonized the relatively bland flavors of the bean sprouts, lettuce, and shrimp chips. Try this one—you'll love it!

The most popular dinner dishes at the Bali are the *satay ayam* (chicken with peanut sauce, cooked on a skewer, $6.75), Singapore barbecued ribs ($7.50), and Oriental Pearls (a simple shrimp dish, $7.50). All the dinners come with the chicken soup, an egg roll, steamed rice, and hot tea. Since Indonesian food is famed for its legendary hotness, I decided to try the hottest item on the menu—*bali daging* (bamboo shoots stir-fried with strips of tender beef in a very hot brown sauce), which was delicious but a bit fiery (not as hot as Tex-Mex dishes I've had along the Border, or some Thai dishes which will instantly cauterize a normal throat). Lestari and her husband plan to add a number of traditional Cantonese and Mandarin dishes to supplement their Indonesian menu, a decision which is probably wise given the cautiousness of most diners in this part of the world. But rest assured, there are many mild dishes on the menu (not *all* Indonesian food is spicy-hot); however, I would strongy urge a party to try at least *one* of the hot dishes (those peppery sauces release a whole series of *other* flavors as well). Indonesian food has caught on in big cities on the East and West coast, and consumers in Springfield

are lucky to have the opportunity to sample such cuisine in the city made famous by Honest Abe.

Another new-wave restaurant with a motel as base is the Saigon (1518 North 30th Street, Corner of North Grand and Dirksen Parkway, next to the Shady Rest Motel, 544-6555). Lam Nguyen, the smiling and friendly proprietor, is another refugee—one of the "boat people" who fled Vietnam after the fall of Saigon (five of his immediate family died during the escape). Lam arrived in America in 1980 and worked briefly at his uncle's Chinese and Vietnamese restaurant in Sioux City before coming to Springfield. He is a talented cook and artist (his self-portrait hangs on the wall), and the rather small restaurant is decorated with dried flower arrangements and a huge aquarium teeming with bug-eyed goldfish.

Service was slow on the Friday night we visited the Saigon—Lam later explained that his waitress was ill, and he (alone) did all the waiting, cooking, and cleaning up for the six or seven tables, as well as handling the take-out orders called in over the loudly ringing phone. Lam kept his cool during the whole evening, and every dish was perfectly prepared. My only complaint was with the first pot of tea which had been allowed to steep a bit longer than necessary, giving it a rather bitter aftertaste. We began with crab and asparagus soup (a delicacy I first tried at a Vietnamese restaurant in Washington, D.C. some three years ago and have craved ever since). The soup was included with the price of the dinner, but I also tried the chicken wings (six for $1.50) drenched in a garlic sauce that is practically addictive. All dinners are served with Vietnamese-style egg rolls (pencil-thin and packed with carrots and cabbage, among other tasty tidbits). We tried the Lemon Grass Chicken ($3.65, spicy shreds of chicken, bamboo shoots, and mushrooms in a savory brown sauce) and the Beef/Mush-room/Cauliflower (a good, basic stir-fried beef with a rich but not glutinous brown sauce). Even though this act approached gluttony, I couldn't leave the premises without trying the Saigon Beef with Noodles (a kind of tomato-based stew with shredded beef and noodles, served in a big bowl—and, yes, we managed to finish it without any difficulty). F. had instructed me to try Lam's famous steam pork-filled bun ($1.15), but, unfortunately, it was not available on the evening of our visit. Lam also plans to add more conventional Chinese dishes to his selections, and he has already tinkered with his menu. I do hope none of the Vietnamese dishes is removed—at least not until I try them.

As should be plainly evident, I am one of those food-oriented souls who cannot long survive without food or the thought of food. In fact, during the composition of this article, with all its evocative smells and textures, I was driven to foraging in my late-night kitchen, coming away with a six-pack of diet Dr. Pepper and two bags of pretzels, which sustained me during the rigors of typing. Some dedicated reporters will do almost

anything to preserve the highest standards of investigative journalism. I visited strange and exotic eateries, labored through a dozen or more dishes, and (sad to say) gained a good pound and a half—all for the greater good of *Illinois Times* and its dedicated readers. I can think of no more suitable conclusion than the sign-off made famous by that most formidable of food personalities, Julia Child, who always ends her discussions of food by wishing her audience an enthusiastic *Bon Appétit!*

In Praise of Pickups

For the refined urban dweller, an appreciation of the humble pickup truck amounts to an acquired taste, something like learning to savor Scotch whiskey, raw oysters, or English madrigals. I say this because the ubiquitous truck may be the most ignored artifact in a typical city scene. I certainly gave no thought whatsoever to trucks, although I took passive note as they went about their yeoman's work, hauling products as diverse as wood and wedding cakes.

But when I found myself transferred to Chicago, the whole complexion of my life changed dramatically. How was I to store those boxes upon boxes of books I had accumulated—to say nothing of antiques, knick-knacks, geegaws, and outright junk? A little economic analysis proved mightily instructive. The cheapest commercial mover wanted a thousand bucks to move my goods some two hundred miles, and so one spring evening I hit upon the expedient of buying a truck for the tidy sum of five hundred American dollars.

Truly, it was no beauty. A 1966 blue and white Chevy, it lacked hubcaps, seat covers, heater controls, inside lamps, air cleaner, door lock, heater core, and other amenities too numerous to mention. I planned to use it a week and sell it off as soon as possible. External appearance didn't matter, I told myself, and, besides it boasted a rebuilt engine, a heavy duty clutch, overload springs, and a specially installed steel floor. All of these features proved invaluable since the old truck faithfully lugged all the furniture that filled my new apartment. In a photograph snapped on that memorable moving day we resembled a group of Okies setting off for the promised land, with coleus and jade plants hanging playfully from the tailgate. It wasn't until three years later that I sold the truck, and the old wood cutter who bought it considered it a bargain at $300. So I paid $200 for a vehicle that moved me happily around the surface of the planet and became the most interesting tool I've ever owned, reshaping my life in ways I never anticipated. It was I, and not the woodcutter, who got the better deal.

Trucks become lovable and intimate possessions in much the same way that unwanted strays (cats, dogs, visiting relatives) drift into the personal spaces of our being and slowly set themselves up as permanent fixtures. A truck isn't an automobile. An automobile gets you from one place to another, but a truck becomes a living space in itself; a toolbox on wheels; a moving canteen; a fine flat surface for cutting planks, stacking plywood, and hauling logs. It becomes a gardener, helping in the acquisition and planting of trees and shrubs. Many times my old steel monster carried a lovely organic cargo of privet hedges, ash, and maple trees—as well as the rich, black manure that smoothed their transition from greenhouses to my back yard. I was to position ladders and scaffolds from the back of my truck, fill it with bicycles and iced-down coolers for summer excursions, and even use it for camping. The addition of a trailer hitch on the huge step-up bumper allowed me to tow a friend's disabled Plymouth sedan over twenty miles of icy roads. With all these virtues to offer me, it deserved some reciprocal gestures on my part. New seat covers, lights, and heater parts came first, and then I gradually replaced every gasket and seal, the worn-out brake linings, and finally the leaky radiator.

Trucks are the last utility vehicles in America. They mesh perfectly with our practical and recreational needs. They are easy to work on, offering cavernous spaces under dash and hood, unlike the cramped quarters of our currently fashionable small cars. Trucks are long-legged affairs that stand proudly on fifteen-or-sixteen inch wheels, allowing the shadetree mechanic easy access to the mysterious undercarriage with its brake lines, exhaust pipes, shock absorbers, and drive train. My truck even provided a cool, shady nook for my neighbor's cat, who invariably located herself beneath the transmission, departing in ruffled distaste when the noisy old truck coughed, sputtered, and finally turned over.

Many of my country neighbors can't bear to be parted from their trucks. They identify with these sturdy vehicles and see them as workaday extensions of their ordinary selves. Many people knew my truck before they knew me. Here, the urban laws are reversed: the shiny new sedan is basically ignored, but the old battered truck looms large in their view of the world. The car, after all, is only a car; the truck is what truly matters.

Perhaps that attitude explains why one of my neighbors totally restored a 1958 Chevy half-ton which he had bought new. It took nearly two years to disassemble the old truck (sheet metal, engine, drive train) and then to re-plate, re-adjust, re-tool, and re-build every single component. Naturally, he refuses to discuss any possibility of sale. The old farmer with the 1948 GMC (still in perfect running order even though it needs a new antenna) asked, "Who can give me what it's worth?" Regularly I see a 1955 faded blue Chevrolet grain truck, hauling soy beans and corn to the local elevator. There's also the fellow with the little green '46 Dodge

(original paint) who inherited the truck from his father and can't sell because the vehicle is already promised to another member of the family. How many Datsuns and Toyotas become family heirlooms?

Those long hours of vigorous outdoor work (gardens, fences, driveways), all involving the truck, created equally strong urges for play and recreation. Perhaps my feelings of affection were first triggered on those days when, still in grubby work clothes, I drove the truck out to the woods, the bed loaded with cut and uncut lumber, hand and power-tools—and, on the front seat, a copy of Henry Hill Collins' *Field Guide to American Wildlife.* In the convenient space behind the seat I stowed my binoculars and a little notebook for recording my various sightings: a wood duck in January, a mallard nest in March, a mother fox and pups in their lair one splendid April afternoon. Deer, those mule-shaped beasts that can suddenly spring and soar like hawks, I ceased to count after a while, they were so numerous. But eastern bluebirds, scarlet tanagers, red-breasted grosbeaks, and orioles deserve special pages all to themselves. I began to lose the sense of tight boundaries between work and play, city and country, road and field. When the road stopped, I just kept driving—as far as the truck would take me.

Wrecked and abandoned trucks tend to assume a kind of spiritual authority over the landscape: they are the totems of earlier, departed people, the arrowheads of a technological clan. Sometimes shrubs and trees grow through rusted fenders and engine compartments. Birds, foxes, mice, and coyotes take to nesting in them. My favorite is an old International grain truck, abandoned for over thirty years in rural Macon County. Perhaps it is fitting that I give it the final say:

> I saw them take the Prairie apart
> Plank by plank: the old barns,
> Oak-boarded and beautiful
> With lightning rods and secret
> Lofts, all disappeared. Family
> Farms dwindled. I don't like
> The new metal barns: will they
> last as long as I have? Look
> At me now, rusted but still sound.
> Sure, I could run again, fill
> Myself with golden grain, richer
> than any king: I would live forever.

Dream Machines

Even eight inches of snow, followed by intermittent flurries, stinging sleet, and blackened slush could not prevent the faithful from flocking to the cathedral-like interior of the Prairie Capital Convention Center to attend the eighth annual "World of Wheels Motorsports Expo," a show which occurs in early January of each year. The event was an authentic American ritual, a cultural potpourri of trade fair, county fair, chatauqua, flea-market, medicine show, and circus. In point of fact, I had last visited the Prairie Capital Convention Center in September to enjoy the Ringling Brothers' Barnum and Bailey Circus, and I was immediately struck by the similarity of the two events: the shameless hawking of geegaws, the glittery overstatement of costumes and cars, the extravagant use of colors like hot pink and mauve, the casual display of things grotesque and bizarre (clown midgets and cars like the "Munster Koach"). There was even a unicorn in each show: a "real" (goat) unicorn which was paraded around like a heathen idol in the Ringling Brothers show-stopping finale, and two airbrushed unicorns embellishing the hood of Richard Cosenetino's 1970 metallic blue Chevy Nova.

I had come to the World of Wheels primarily to meet George Barris, the self-styled "King of the Kustomizers," a wiry and genial little fellow in a yellow sateen jacket, T-shirt, cord pants, and silver-tipped cowboy boots. Barris had been immortalized as one of the original heroes of the car culture in Tom Wolfe's classic piece of new journalism, *The Kandy-Kolored Tangerine Flake Streamline Baby*. In postwar Hollywood, Barris basically invented the custom car, using "free form" designs reminiscent of Brancusi and other modern sculptors. What Picasso is to Cubism, Barris is to modern automobile design, since the Barris designs eventually filtered up to the conservative design studios in Detroit. Barris designed the Batmobile for the old *Batman* TV show and the Munster coach ("with real coffin handles on the doors") for *The Munsters*. Barris also designed special cars for any number of Hollywood moguls, including Elvis Presley, Dean Martin, and John Travolta, among others. Barris is also a professional

stunt man and part-time actor, and he has worked closely with Burt Reynolds (whom he admires greatly for doing his own stunts), especially in *Smokey and the Bandit*. But on this snowy night, Barris is standing in a corner of the convention center, mike in hand, hyping up the volume and tempo like an old carnival barker, putting in plugs for Batman (Adam West) in the other corner, and various sponsors like Kenwood Stereos and Team Electronics. He's promising the rag-tag crowd out-takes, film-clips, and rare footage of car crashes and world-class stunts "direct from Hollywood" (he repeats it three times like an incantation). The crowd doubles in size, and then it doubles again. Suddenly over a hundred people are being hypnotized by George and his rapid-fire delivery. Like magic, a curtain snaps open at his side, and a rear-projection camera shows clips from *Smokey and the Bandit, Hardcastle and McCormick,* and *The Dukes of Hazzard* (for which he built 31 copies of the General, 14 of which were demolished during the filming). The scenes are riveting enough, but Barris pumps the crowd up even more with remarks like: "The stunt man is equipped with a girdle so he doesn't blow out his guts when he hits the ground." And while discussing the filming of *The Junk Man,* he calmly observes: "We crashed more cars [150] than in any other film in the history of film-making."

Barris identifies himself as a craftsman, and he surveyed the eighty some odd cars in the show with an air of pure satisfaction, complimenting all the local artisans. "The quality of the show is very good," he pronounced. When I asked him to comment on the decline of the American automobile industry, he instantly shot back that it was "our fault," and blamed our "quality of workmanship," something he (and the other exhibitors) value most highly. "Our worker lost all sense of craft," he laments. "He became too interested in striking than in making a car his neighbor would enjoy driving." Barris admires Lee Iaccoca for resurrecting the Chrysler Corporation, he likes the new Ford designs, but he particularly praised General Motors designs like the Trans Am, Camaro, and Corvette. I watched Barris autograph his publicity photo, while talking with all of the crowd. The man genuinely enjoyed meeting people, flashing smiles, asking names, offering opinions. Like his designs, he struck me as an absolute original.

It was a little harder, however, to accept Adam West, star of the 60's campy TV dramatization of *Batman* comics. Sadly, Robin (his adolescent sidekick) was not on the scene, and Batman had gone a bit soft in the middle. Besides, there was something indescribably tacky about a grown man prancing about in a purple body stocking, vinyl briefs, vinyl boots, and matching vinyl cape. The illusion (from TV and the comic strips) was shattered forever, but Adam West's voice still possessed that same predictable disc-jockey phoniness, a sort of epicene tonality that inevitably draws

large crowds of autograph-seekers, photographers, and one improbably loyal fan with an original 3-D *Batman* comic book in which the 3-D glasses were still stapled to their original card inside the comic book.

If Batman Adam West suggested that the comics had come to life, a walk in almost any direction from his corner suggested that the cars had become as fantastic as the comics. One stood in awe of automobiles, vans, trucks, motorcycles (and even two speedboats) in every possible color and configuration: cars propped up at odd angles, cars without wheels, revealing chrome-plated brake drums and lugs, cars with mirrors underneath to reveal chrome-plated axles, differentials, and frames, cars all gussied-up, glitzed, and waxed to a state that could only be called Art. It may be popular art, bad art, or even outrageous art, but the customizer isn't a hot-rodder or a grease-monkey. The customizer is in the business of creating illusions and fantasies by bringing to life in lacquer, chrome, and fiberglass every permutation of dreams about automobiles.

These dream machines are typically displayed in carefully staged settings or ambiances, like the island setting evoked by Bill Miller's "Touch of Paradise" 1983 Ford van, painted in blue lacquer and displayed on a sea-blue carpet from which a section has been removed and filled with white sand, driftwood, and seashells. A pirate ship and palm trees were airbrushed on the side of the vehicle, and the interior was finished in wood to resemble an old Spanish galleon (it was furnished with a globe, a ship in a bottle, a real ship's wheel, and mounted cutlasses on the wall). There was even angel hair in the exhaust pipe to suggest a puff of smoke and to add to that final touch of unreality—was it a Ford van or a scene from *Treasure Island*?

Or consider the musical mood created by Monte Keltner's 1955 Chevy Nomad station wagon, sprayed with a "Brandywine Metallic" paint. The windows of the car are a testament to the rock and roll music of the 50's. A musical staff and notes are engraved (not painted) on the vehicle's windows, accented by an engraved pair of boppers (the girl even sports an authentic "poodle" skirt, the garment of choice for "hip chicks" in the mid-50's). Rock and roll was in the air as well, piped and reverberating throughout the center's excellent speaker system. Golden oldies like Jerry Lee Lewis' *Whole Lot A Shaking Going On* blasted through the high-vaulted space, followed by Chubby Checker's *The Twist*, The Beach Boys' *I Get Around* (an appropriate tune for an automobile show), and Bill Haley's *Rock Around the Clock*. I spoke to two cassette-tape vendors who were selling tapes by Johnny Mathis, Marty Robbins, Gene Autry, The Lettermen, Elvis, and Tanya Tucker. Their best sellers, I learned, were Chuck Berry, Jan and Dean, and Patsy Cline. Other vendors hawked such items as hat tacs (those little metal badges pinned to baseball caps), flags (Texan and Confederate), earrings, gold chains, knives, belt buckles, bandanas, and (of course)

toy cars. There were also purveyors of giant chrome-plated roll bars, car wax, and sexist calendars featuring scantily-clad models posing next to powerful machines.

Not for sale was George Barris' Munster Koach, which stretched eighteen feet long and was composed of three Model-T bodies. It sported brass side lamps, front brass lanterns with spider webs painted on them, coffin handles for door handles, and red velvet coffin cloth for upholstery. Barris' other famous car, the Batmobile, was not on display (although it *was* on display at *last* year's World of Wheels). Another much-advertised car in the show was the lipstick red 1982 Lamborghini Countach (pronounced "coon-tash"), which is powered by a V-12 engine that propels the wedge-shaped little vehicle to speeds in excess of 170 miles per hour. Of course, the Countach delivers a mere ten miles per gallon in city driving, but anyone who can afford it (the 1982 price was $118,000) probably doesn't worry about fuel economy or the latest quirky move on the part of OPEC. The doors on this little sports car open straight *up* and travel on hydraulic pistons in what is known as "scissors action." I gleaned this last piece of information from a dreamy-eyed young man with a baby girl on his shoulders. He stood next to me, eyeballing the Lamborghini. "I've got the blueprints for that car," he whispered in my ear and then proceeded to run through every detail of the car's history, even telling me where I could buy a replica (just the body, no engine) for a mere $10,000. Like George Barris, this fellow didn't *talk* about cars—he practically *sang*. All over the floor, similar exchanges were taking place. I stood next to a woman who was admiring a silver Corvette that looked as if it were covered in numberless little sequins. She kept telling me it was beautiful, over and over again.

Most of the spectators admiring Sid Joseph's 1966 metallic purple Corvette were rendered speechless. The car has special gull-wing doors, and it was displayed in a giant brass-railed octagon with stained-glass insets. The Corvette was tilted at a rakish angle, shown without wheels, and surmounted by a triptych (three hinged panels of the kind used as medieval altar pieces) featuring Roman soldiers killing a lion. I'm not precisely sure how a Corvette gets blended into Roman civilization, but perhaps the car became a catalyst, or maybe a release, for imperial fantasies—and for all the potential feelings of danger and excitement brought on by a fast and nearly uncontrollable sports car. By contrast, George and Ron Metzger offered a scrupulously pure 1969 "Sterling Silver" Camaro, a kind of minimalist statement in this world of overkill and overstatement. Clearly meant to be viewed as a work of art, this car could not possibly run: the engine, all chrome and gold plating, rested in a painted engine compartment without connecting linkage, hoses, belts, or fuel lines—a kind of abstract *statement* about engines and cars, executed in tones of chrome and silver.

On the other hand, Chuck Taylor's 1938 "Spruce Green" Chevy sedan definitely *did* run, for Chuck had driven it to the center the night before the snow storm hit the city. Believing the show was for traditional, restored cars, Chuck entered the '38 Chevy—and was accepted (as were the owners of several other restored cars). Chuck bought the car in Illinois, in running condition, although he found the running boards in a chicken coop in Missouri! The car was beautifully restored, even down to the hubcaps: Bogart himself might have driven it (or one like it) in *High Sierra*. I must admit I was also drawn to three other restored Chevies: a 1950 Chevy Pickup owned by Don Cutler. It was painted a brilliant "Cream Yellow" and reminded me powerfully of a similar truck owned by my grandfather. I also admired the sharply contrasting lines and colors in Jim Horlacher's 1969 yellow Camaro convertible. But my unequivocal favorite was Mike Atteberry's 1955 Chevy Bel Air, black and white with a charcoal gray interior as shiny as if it were still parked in the showroom.

I suppose I had come to observe the spectacle dispassionately, and maybe take one or two cheap shots, but all that aromatic lacquer and glistening chrome, combined with the jostling crowd and the jackhammer pounding of the rock and roll, worked a general metamorphosis on my consciousness. After four hours in the auto show, I was designing dream cars in my head and fairly bopping down the sidewalk when reality hit me in the guise of my 1974 Chevy truck, sad and snow-covered. I drove home in a real truck with 153,000 miles on the odometer, over the snow-packed and hazardous roads of Illinois. Snowflakes fell everywhere, as heavy and dusty as moths. For four hours I had been in a museum of cars meant for heavenly roads, not the ordinary roads of this pot-holed universe. Yes, even machines could be made into dream art: that is what I had learned. The wheel in my hand seemed to be driving, in succession, every gaudy and kinky car I had seen that evening. In the middle of a blinding snowstorm I experienced a delirious sensation of pure freedom. I had been customized.

The Rise and Fall of the Decatur Comet

Three or four generations ago Decatur, Illinois, like dozens of other manufacturing towns in the Midwest, began to position itself as a parts supplier in the burgeoning automobile industry. The first commercially successful automobile in America had just appeared in 1896, evolving from plans drawn by the Duryea brothers in their shop in Peoria, Illinois. Ten years earlier, in 1886, the world's first practical automobile had been invented in Germany, so 1986 is being celebrated as the "Century of the Automobile." 1986 is also the Year of Halley's Comet, a celestial display last witnessed, in a much more resplendent form, in 1910. Halley's comet must have impressed automobile designers in the Midwest because some of them developed a new automobile in Rockford, Illinois in 1916 and named it the Comet. Within a year that car was being mass-produced by the Comet Automobile Company of Decatur, Illinois.

Decatur was home to many important engineers and inventors. A. W. Cash invented a valve which was used on the U. S. Navy's first submarine in 1895, and another one of his valves was used extensively on the gates of the Panama Canal. In the World War One era, James Blair invented an electrically-operated turn signal known as the "Safdicator"; it featured a little tin hand that pointed its index finger in the direction of the turn. One of Blair's customers was the Comet Automobile Company. R. H. Campbell invented the flexible neck oil can while he was employed by the Comet firm.

That oil can has become so commonplace that it is now taken for granted. But perhaps the most important Decatur inventor was Hieronymous Mueller, an immigrant who had perfected a device for tapping water mains. That device is still in use today, and it formed the basis of Mueller's fortune, allowing him to start a business in iron and brass working that operates today as the Mueller Laboratory.

In 1895 Mueller bought a Benz Motorwagon in Germany and brought it to the United States. Mueller's car was one of the first automobiles in the Midwest and certainly the first in Decatur. Mueller was a

talented engineer, a born inventor, and an unbridled automobile enthusiast. After winning the first U.S. automobile race in Chicago (in 1896), he decided to make various improvements and additions to the Benz Motorwagon, and he took out a number of automotive patents dealing with changes in the transmission, steering gears, water-cooling mechanism, and electrical system. Mueller had drawn up blueprints for an automobile factory to manufacture the "Mueller Benz," and Decatur was on the verge of entering the world of automobile manufacturing when Mueller died from a gasoline explosion on March 1, 1900.

The first automobile companies were really just expansions of the carriage and bicycle trade. Early autos could properly be described as light carriages with bicycle tires, steering tillers, and small gasoline engines. Decatur, of course, had scores of carriage shops, bicycle shops, and all sorts of foundries and metal-fabricating companies. Decatur was a natural transportation hub as well, being located in the center of a rough triangle whose points were formed by the cities of Chicago, St. Louis and Indianapolis. Decatur was served by three railroads: Illinois Central, Wabash, and Norfolk and Western. Decatur was also known as "Cross Roads City" because it occupied the intersection of the only two continental highways then in existence—the Ocean Highway (San Francisco to New York) and the Meridian Highway (Ontonogan, Wisconsin to New Orleans). In short, Decatur had the infrastructure (as we would call it today) and the skilled workmen to produce automobiles on a large scale. Undoubtedly this potential for automobile production caught the eye of two groups of businessmen operating in Northern Illinois in 1916. One group, headed by George W. Jaegers in Rockford had designed a new medium-priced car called the Comet, and a prototype was to be shown at the Chicago Auto Show of 1917. The Pan American car had actually been produced in small numbers in Chicago when the company's president, Edward Danner, decided to move its offices and set up a plant in Decatur, just as Jaeger and his Comet Company had already planned. So in early 1917 Decatur suddenly found itself hosting two car companies that competed for one another's business and for the patronage of local consumers. The Pan American did not catch the public's attention in the same way as the Comet did; it never established a permanent plant in Decatur, and the company folded in December of 1921, after a major scandal involving the treasurer, a local man names W.A. Phares. Phares absconded with $23,000 of Pan American's capital, thus assuring the fledgling company's downfall. He was later indicted, convicted, and sentenced to fourteen years in prison.

Danner, Jaegers, and their many investors may have decided to plunge into automobile manufacturing because in 1917 the country was riding a wave of automobile hysteria. In 1916 over one and a half million

automobiles were already on the American roads. Those Flivvers and Tin Lizzies were manufactured in over 450 factories in thirty-two states, producing over five hundred different makes of cars. Cars traveled over fifteen billion miles per year consuming twenty million barrels of gasoline and riding on twelve million tires. Cars were sold at almost twenty-six thousand local dealerships. So before the U. S. entered World War One, the automobile was already a dominating presence in American life, both statistically and economically. Directly or indirectly some two million Americans depended on the automobile for their livelihood.

Unlike today in an era of gas shortages, recalls, traffic jams, "outsourcing," and environmental concerns, automobiles in the late teens were imbued with an air of romance and a tinge of dangerous excitement. Roads were alternately muddy as hog wallows or dusty as desert trails. Largely unmarked and unpaved, they tested the driver and the vehicle in every way imaginable. Roads around Decatur and Central Illinois were often called "trails"—even on official maps—and carried such names as Abe Lincoln Trail, Kickapoo Trail, Caterpillar Trail, and Garageman's Trail. Axles snapped in deep potholes, radiators boiled over on scorching summer days, and tempers raged through all these calamities. Local papers carried columns with titles like *Auto Notes* and *How are the Roads?* People who bought a new car usually merited an article in the paper. Arriving from a sister city by car also meant a squib in the local rag. During the time of the spring rains, when mud rose up to the axles, a trip from Quincy to Decatur typically took a day and a half-assuming there were no mechanical breakdowns. Motels were unknown, and some motorists rented a farmer's barn for the night or slept in the open fields wherever possible. Even trips in town could be exciting. Many motorists were just learning how to operate their cars; brakes were something of a mystery to novice drivers. Bicyclists were sometimes bumped from behind, and pedestrians were occasionally squeezed between colliding bumpers.

In this era of cheap silent films, penny candy, and nickel lunches, a gallon of gas could be had for twelve cents. Speed limits were just being introduced in Decatur—ten miles per hour in residential areas and a zippy thirty miles per hour out on the open road. Railroad stop signs were also making their first appearances. The Chicago Auto Show and the Indianapolis 500 were well established as annual events, and these rituals were followed with great interest by the local population. Tom Alley, a Decatur man, was one of the famous race drivers of the day, enjoying the same kind of national attention as Ralph DePalma and Gaston Chevrolet. Road races and endurance runs were always well covered, and manufacturers (like Comet and Pan American) took advantage of these events to get a maximum amount of free advertising and exposure for their machines. Decatur consumers had many automobiles to choose from, not

merely familiar makes like Ford, Buick, Cadillac, and Chevrolet but cars with strange and exotic names like Whippet, Hupmobile, Reo, and Hudson Speedster.

Automobiles were simply the most visible (and the most expensive) items in what had clearly become the Age of Consumerism. Many familiar products, like Ivory Soap and Vicks VapoRub, had already made their appearance. In this world of Lydia E. Pinkham's Vegetable Compound, Fletcher's Castoria, Fatima Turkish Cigarettes, Buster Brown cartoons, and Charlie Chaplin films, the Comet made its debut on February 23, 1917. In less than a month President Wilson declared war on Germany.

Suddenly Decatur citizens were swept up in war hysteria and passionate displays of patriotism at the same time that they gave their attention to the Comet. Victory Gardens sprouted all over the city, and like the rest of the nation Decatur went on the War Bread Diet. Reverend Frank Fox of the Congregational Church delivered a dramatic sermon on American principles and ended the sermon by seizing the flag in the pulpit. Mrs. William Downey literally wrapped herself in the American flag and gave her pantomine of "America" to many local audiences. Patriotic poems appeared in broadsides and newspapers. The following stanza, from Borton Braley's "The Call," is fairly representative of the prevailing style and tone:

Uncle Sam's Navy
Sailin' "the wavy"
Makes you a jackie—a good man and true!
Want to be sharin'
In danger and darin'?
Uncle Sam's Navy is looking for you!

The German Methodist Episcopal Church of Decatur, established in 1887, suddenly found itself without a congregation as the Germans abandoned their church lest they be branded as unpatriotic—or even subversive. Buster Brown cartoons of the day show Buster stealing items from German delicatessens while Tige, Buster's faithful dog, signs up for the U.S. Army dog patrol. Everyone participated in the war effort, and unlike other parts of the country (the urban northeast, for example) Decatur turned out enthusiastically for this war, as it had for others.

So the fate of the Comet and, to some extent, the industrial future of Decatur were tied inexorably to the events of World War One. On the one hand, the Comet was naturally perceived as part of America's industrial might, an investment well worth preserving in a time of peril. On the other hand, the production of the Comet car proceeded by fits and starts during the entire existence of the Company (from February 23, 1917 to March 29, 1924) both because of irregularities caused by wartime ration-

ing (especially affecting stocks of steel and coal) and because of anomalous economic conditions that followed the war (shortages of consumer goods, high inflation, strikes, and deep recession). In almost every respect the history of the Comet is a history of the economic impact of World War One on small entrepreneurs. Had America not entered the War, there is a reasonable chance that the Comet would have survived. With luck, it might even have flourished.

Luck, however, was in short supply for many manufacturers in 1917. A natural winnowing or "shaking out" was occurring in the automobile industry as a whole—a situation not unlike that of the computer industry today. By 1925, the domestic automobile market was completely saturated. As if that weren't enough, large producers like Ford were buying out smaller companies and forcing others out by deliberately lowering prices to levels that were ruinous for the small competitors. Even if Ford had not been around, the Comet would have needed divine guidance to escape the larger forces of the American economy. During the years 1914 to 1920, the cost of living rose 104%. It is small wonder, then, that returning doughboys found themselves unable to make ends meet on the meager salaries they were paid. Strikes followed, especially coal strikes, which in turn curtailed the production of steel. Small companies like Comet, which had neither the resources nor the space to stockpile large quantities of steel, were crippled.

The uneven flow of materials to the Comet factory can be detected in the production of the very first Comet car which was begun on May 27, 1917 but was not actually completed until July 16, 1917—almost two months later. At the peak of production, in late 1919 and early 1920, about 5 or 6 Comets were produced a day in the impressive new plant located at 800 East Garfield on the city's north side. The interior of the building was as long as two football fields, and the walls were made almost entirely out of glass, allowing maximum amounts of light and ventilation. The Comet plant was no sweat shop—it was clean, modern, and functional in every respect: skilled workers earned a respectable $37 per week. Special railroad sidings and large loading docks facilitated unloading of parts and supplies and loading and shipping of the finished cars.

The Comet was available in yellow, dark brown, green, and deep blue. With its "streamline double cowl body" and rakish tilt to the hood, the Comet was a sporty and attractive vehicle, about on the level of a Pontiac or Mercury in today's market. The Comet was shipped to many locations in the U.S. and to such foreign countries as Belgium and Denmark. At a time when the Ford Model T cost about $500, the Comet was always an expensive (though not luxury-class) car. In 1917, it cost $1,085; in 1919, $1,865; in 1920, $2,150; in 1922, $2,300. Thus the price of the car more than doubled in five years, a fact which accounts for the

relatively slow sales in the depressed local market. It is worth noting here that the price of recent American cars in the period 1976-1981 increased almost as dramatically as that of the Comet from 1917-1922—and with the same ruinous consequences. If the Carter administration had not intervened, Chrysler surely would have gone the way of the Comet. All told, the Comet Automobile Company produced about 1,500 cars, but in September of 1922 the production line came to an abrupt halt as the company went into receivership. Comet owed $60,000 to the banks and $75,000 to its other creditors. In simplest terms, Comet had gone broke, and its collapse foreshadowed the ruin of hundreds of other businesses after the Crash of 1929—and, more recently, after the deep recession of 1979-1981.

The Comet factory, however, continued to play a part in Decatur's industrial history. The L. P. Halladay Company purchased the building and twenty acres of land for $125,000 on March 29, 1924. Halladay manufactured bumpers there until 1936. The Houdaille-Hershey Company owned the plant from 1936 to 1957 and manufactured a large quantity of shells for the U.S. Navy during World War Two. Western Electric Company owned the plant from 1957 to 1958, but the building stood vacant from 1959 to 1965, when it was purchased by the Essex Wire Company. In 1981, however, Essex moved its operations to plants in Tennessee and Kansas, after laying off some 350 men. Today the Comet factory stands empty once again.

The history of the Comet Automobile Company and of Decatur as a manufacturing center parallels that of a dozen or so other midwestern cities, all "feeders" for the automobile industry—towns like Anderson, Indiana; Clinton, Iowa; Peoria, Illinois; Flint, Michigan, and Youngstown, Ohio. In October of 1982, Decatur ranked second in the nation in unemployment with a jobless rate of 19.9 percent. Only Youngstown, Ohio was worse, with a rate of of 20.9 percent. In 1983 many of the major manufacturers of Decatur—including Caterpillar Tractor Co. and A.E. Staley Manufacturing company, the two major employers—threatened to leave the city. They have stayed, but only because of cutbacks in production and layoffs in personnel. Between October 1, 1982 and February 1, 1986, Decatur lost 3,273 jobs. The pattern of decline set at Comet some sixty years ago appears again and again in Decatur's auto-related firms, especially at Borg Warner with its largely deserted parking lots. In all the Midwestern cities that feed Detroit its batteries, headlamps, tires (Firestone has a plant in Decatur, also scaled down), carburetors, and air conditioners (also made at Decatur's Borg Warner in its York Automotive Division), everyone seems to be waiting for the End.

What would happen if all these Midwestern suppliers pooled their resources to produce a car eminently suitable for today, as the Model T was for the population of 1908? Wouldn't Hieronymous Mueller and all the

other Decatur inventors applaud such an effort? After all, Steven Jobs started a revolution by making the Apple Computer in his garage. Is it possible to have a second automobile revolution, one based on radical changes in the engineering and design of the automobile? Such is the hope of the Saturn, another car with astronomical symbolism in its name, soon to be produced by General Motors in the small town of Spring Hill, Tennessee.

It seems appropriate to raise these questions in 1986, the Centennial Year of the automobile and the Year of Halley's Comet. Today one might stand in the empty building at 800 East Garfield on a sunny summer afternoon, with sunlight streaming through the glass walls, imagining the sounds of rivet guns, drills, and sanders—all the clanks, scrapes, buzzes, and thumps that accompany the production of an automobile in a pre-robotic age. One can imagine a sleek yellow body, freshly painted with heavy enamel, moving slowly through the dust motes, its wire wheels glinting in the sunlight, its supple leather upholstery inviting to the touch. This is only a reverie, of course, but it is the nature of Comets to appear brilliantly, recede suddenly, and after an interminably long absence, reappear, and dazzle us with their light.

Bel Air: The Automobile as Art Object

On one of those high, dry October days when the sunlight spills warmly into your field of vision and the icy tang of winter clings to the edge of consciousness, I found myself driving over the bad farm roads of east central Illinois. The countryside was geometrically neat and planar: corn and bean fields fell in regular intervals like squares on graph paper or the blue lines of a surveyor's notebook. I was heading toward the Indiana line, and even now the land was no longer flat as a table top but began to undulate and dip into ravines, hills, and little sandstone cliffs. The roads turned serpentine and narrow, enclosing an apple orchard here or a herd of fat Holstein there. Everywhere the sunlight was falling in big, manageable chunks, illuminating the farmhouses as formal as postage stamps and the sharp-edged red barns that must have been cut out with scissors and pasted to the horizon.

Everyone feels rich at harvest time, and perhaps that is why these farm folk who raise the corn and apples delighted in horse-trading, auctioneering, flea markets, barn sales, and open-air swap sessions. I had already passed two auctions in progress, and I would have passed up the next one except for an especially severe glint, a blister of light that emanated from the heavily chromed snout of a 1936 Packard. I half expected FDR to be sitting on the back seat. This sedan stood tall and stately, and the farmers approached it with a certain air of hesitation and respect. A 1929 Model A seemed more democratic and inviting, even though it did have traces of rust on the rear fenders. But the showpiece was a 1950 powder-blue Ford Tudor, "slick as a bar of soap and smooth as a sewing machine," according to the old farmer who owned it. Clearly, this was no ordinary flea market; serious collectors were sprinkled among the farmers in overalls, plaid shirts, and John Deere caps. Although the sermons were better, the prices were too steep for my professional salary. "Tell you what I'm gonna do," said the owner of the blue Ford. "Feller up the road, friend o'mine, has a Chivvy fer sale," he explained, as he pointed

toward a hill some two or three miles distant. "You jog left at the crossroad and follow the hard road up the hill. You can't miss it."

The crudely lettered sign CAR FOR SALE was planted in the front yard of a white frame house that might have served as an archetype of the region. No one seemed to be around, so I ambled into the inviting red barn, with its rich texture of smells: timothy, alfalfa, manure, and mud. The cracks between the old barn boards were thinner than knife blades, allowing the cool October light to squeeze through like thin sheets of glass. Dust motes hovered everywhere. There was just enough light to discern the straw-covered outlines of an automobile resting in the corner like some found object. Here was no Victrola or tacky butter churn; here was a piece of pure Americana, a 1958 Chevrolet Bel Air sitting glumly on tires that were squashed flat and useless. A bale of hay had fallen on the roof. A rusty-colored chicken sat pensively on the back seat. Yet the sheet metal, lacquered in alternating bands of metallic blue and creamy white, still glowed impressively. This old sedan arched its metallic eyebrows over the four intact headlamps, and the front bumpers were puckered open and spread wide like a shark's jaw filled with numberless teeth. I was drawn especially to the turquoise blue interior, the dashboard and instrument panel composed in sweeping parabolic curves punctuated by conical knobs and switches in a style that was pure Buck Rogers. A shape reminiscent of the fabled V-2 rocket had provided a decorative motif that was repeated on the upholstery of the doors and seats.

This Bel Air was Everyman's Space Ship for 1958, an artifact from a happier and dreamier time when space ships and their telltale fins had charmed the national imagination. In the year before this Bel Air left the assembly line in Detroit, Sputnik was launched. Eisenhower was ensconced safely in the White House, Elvis was king, and the Cold War was turning icy-hot, as suggested by the Civil Defense "Conelrad" logo on the radio dial. Somehow this car had cheated the inexorable march of time, like the strange, captured moments of a prized photograph. But unlike the photograph, the Bel Air was not a ghostly image but a three-dimensional presence, enticing and seductive in its pure physicality. I dimly understood that by possessing this car I was retrieving part of my past and—through a kind of Proustian logic—expanding my present. The good hard money of the 1950s could still be spent; the music persisted, not merely the music of lovers' lanes and hamburger heavens but the deeper strains of a past recaptured. Rock and Roll pounded in my temples; the hiked-up bass lines of electric guitars ricocheted in the close, cabin-like interior of the old Chevy. Some dark-haired singer in a gold lame suit intoned pleadingly into a microphone; the rhythms grew stronger and stronger, overwhelming in their intensity. Like so many before me, I found my virtue and good sense powerless before this onslaught. And I bought that car.

Some days later a tow truck deposited the Bel Air in the driveway of my house on Faculty Row, adjoining the grounds of the starchy liberal arts college where I taught literature and writing. Something was dreadfully out of place. The car was older than most of the students. Surely the Prof was off his rocker for buying such an old junker! A neighbor and colleague, indignant and peeved, demanded that I remove that "relic" from the driveway. Property values were going to suffer, he insisted. As if to exacerbate my feelings of guilt and squeamishness, the local Chevrolet dealer refused to touch the car. The service manager, in fact, broke into peals of laughter when I timidly admitted that the car was a '58. Apparently Mr. Goodwrench was as phony as any other character on television. No independent garage wanted the work either. Even a so-called "custom" shop saw no profit in the undertaking. I now owned a piece of collectible kitsch, something to frame and elevate as an art object in the manner of Joseph Cornell, the artist who spent a lifetime making glass-framed boxes which he filled with various *objets*.

But if the automotive establishment wasn't interested in a disabled 1958 sedan, many other people obviously were. The doorbell began to ring daily, and inevitably a stranger appeared, asking about The Car. Was it for sale? How had I found one in such excellent condition? Was it a straight six or a small-block eight? Did I plan to exhibit? The most interesting visitors were those who, like the rural antique dealers, wanted to swap stories. One fellow recounted in vivid detail a trip that he and his family had taken to the Yukon in a 1958 Bel Air. Others rehearsed first dates, proms, traffic tickets, and other small moments of family and personal history. Although the stories, for the most part, amounted to trivial and corny tales, the act of nostalgic recollection and the process of retelling were genuinely impressive. An American paradox was parked in the driveway, an assemblage of insensate rubber, steel, and glass parts that somehow triggered poignant human feelings. A college dean, who usually spoke in terms of "cost benefit analysis" and "management by objective," arrived one morning, asking to inspect the ancient oil-bath air filter. He then gave me an impromptu sermon on the virtues of this 250-cubic-inch straight six engine, closing with the colloquial observation that "these here motors will run forever. You could hit 'em broadside with a bazooka, and they'd still keep running." I had never heard those tones in the official memoranda he sent through campus mail. By this time, I suspected that I had fulfilled every anthropologists' secret dream: the discovery of an authentic tribal totem. When these visitors spoke of the Bel Air, their tones shifted, and their voices fairly rose in song. One man produced a billfold in which, next to snapshots of his wife and kids, were pictures of the three '58 Chevies he had owned, including an Impala convertible, black and shiny as a hearse. The Bel Air had provided an entree for each of my

visitors, and something indisputably human in their own past had suddenly become larger and more accessible. Like the car itself, memories were being towed out of some red barn and made ready for restoration.

Buck and Larry appeared on the doorstep like all the other strangers who had come to see The Car, but from the very first moment I sensed that our association would be different. For one thing, in dress and manner they resembled dropouts from some Tantric California commune of the late Sixties. Larry was a vegetarian who sported a red beard down to his chest, and he generally spoke about the beauty of "natural and organic" ways—when he spoke at all. Buck was a dark and loquacious fellow with old-fashioned wire-rim glasses that bobbed up and down on his nose as he laughed nervously and launched into frequent jokes or sarcastic anecdotes. Although they tried to pass themselves off as young innocents, I later learned that Buck had a degree in anthropology and that Larry had completed everything but the dissertation for a Ph.D. in biology. During the time I knew them, they asked me more pertinent questions about philosophy, literature, and world affairs than did most of my students— or even my colleagues, for that matter. They read voraciously, and they fixed old cars. Lesson number one: a book is a tool.

They sized up the car with a cool, professional savvy, checking tie-rods, A-frames, wheel bearings, gear lube, and throttle linkage while petting the metallic flanks of the old Bel Air as if it were a pony about to receive its first saddle. At first I thought these automotive guardian angels fit into some convenient sociological niche, like "hippie hot-rodder" or "blue-collar buff" or "nostalgic collector." Actually, they belonged to a more original category that I dubbed *homo mobilis,* self-reliant, Emersonian types who believed that "less was more" and that maintenance was a way of life. Keep it running, keep it running, and above all, do it yourself. Since the age of twelve or thirteen, Buck and Larry had torn down and reassembled every kind of engine they could get their hands on: motor-cycles, lawn mowers, outboard motors, even garden tillers. They had learned to trust the palpable reality of the well-tuned motor as much as they learned to distrust and despise automotive dealerships with their sinister wiles and shoddy business practices. Well, I had started off in the right direction, they assured me, by buying the car from another individual (never from a dealer, new or used) and by buying a used vehicle that was potentially road-worthy. At this point, I had my doubts. The thing hadn't run in years. Belts were loose, gaskets were brittle, valves and rocker arms were painfully out of adjustment. The carburetor sprayed gasoline in fan-shaped spumes over the entire engine compartment. Could this lethal, incendiary weapon be transformed into a civilized sedan, after all? As if to answer my question, Larry shuffled over to his pickup and returned with a tube of industrial-grade sealant and a small crescent wrench. After

a few minutes of tinkering and a boost from the truck's oversized battery, the old Chevy fired up, coughed throatily, and began to turn over in a rough but regular rhythm. "Needs work," observed Larry.

That laconic utterence translated into six weeks of intense physical and intellectual exertion of a kind and combination I had never experienced before. We all had jobs, but every afternoon, Larry and Buck appeared with whatever tools, jacks, torches, lights, and meters were dictated by the task at hand. In the end, we stripped the car down to its bare bones, piece by piece, even the maddening watch-like interiors of the carburetor, speedometer, and clock. When we finished, some six weeks later, at a time when the first snow was beginning to dust the ground, the car was mechanically perfect and aesthetically pleasing, with one small exception. The electric clock proved intransigent to the very end; Buck concluded that it would always gain five minutes per week, that it was probably a design defect. I never learned if that was a face-saving rationalization on his part, but it was the only time Buck or Larry ever offered an excuse. In their view, everything on a car behaved according to immutable principles of logic and right reason. If anything malfunctioned on the car, there was always an exact and assignable cause for the problem. Unlike the world of men and ideas, where reality was surrounded by a nimbus of confusion and doubt, the systems of the automobile obeyed laws of a Platonic and Newtonian kind.

I began to appreciate the subtle meshing of one part with another and the larger coherence of whole systems of parts (engine, drive train, brakes). Precise articulation was the goal here as in the teaching of rhetoric. If the front wheels were out of alignment, then the tires would wear unevenly and commence to wobbling at high speeds. This vibration, in turn, would weaken the tie rods, and eventually grind down the rubber bushings until the car would be next to impossible to steer. On the other hand, if one had the precise point of alignment for every system, the whole car began to behave with a beauty that was proved in flawless acceleration, cornering, and braking—and in the knowledge that these small parts of the universe hummed perfectly. Hence, the ignition points must be separated by a gap of exactly thirty-five thousandths of an inch for reasons of engineering as well as aesthetics. So too, the timing was adjusted exactly five degrees from "top dead center." I never heard Buck rhapsodize about the special beauty of the automobile, but one splendid afternoon when the western sky was flaring and we had finally returned the last pieces of chrome trimming to their proper places, Buck caught me staring at the finished product. For once, he was speechless. His face crumpled into something like a smirk or a wink before he loaded the last of his tools on the bed of the truck. He and Larry drove away, looking for all the world like the Robin Hoods of the automotive kingdom.

Although Larry and Buck might have earned hundreds of dollars apiece for the work they performed, I knew better than to offer them money—despite the fact that the Bel Air had quadrupled in market value. Our exchange had been more educational than mercantile. Buck and Larry would have never used the word, but they surely taught me that an automobile, first, in its operating parts and, second, in its repair and maintenance, amounts to a kind of logos, a self-contained system of causes and effects, a wholeness of truth and reason. Automobiles, which had heretofore baffled me with their perverse and irrational breakdowns, now seemed tractable and sane. Furthermore, working on an automobile provided one with a sense of control that carried into every department of human life. No one would want to be guided by the strictures of Chilton's Repair Manual, but how refreshing it would be if our scholarly and political discourse approached the clarity of the manual. Words like knurled, tapered, and pitted were semantically pure in a way that terms such as liberal, symbolic, and axiomatic rarely were. One night after reading chapters on gears and ratios in Chilton, I picked up a recent issue of the Publications of the Modern Language Association and found myself translating the critical jargon into something like plain English. Other tilts occurred, also. Even though I punished my hands and arms with special soaps and brushes, ultimately I could not conceal my secret life as a devotee of oil and pistons. Immovable sludge from the heart of the old engine lodged permanently under my fingernails and cuticles. Ground-in blackness darkened the whorls of my fingerprints and the tiny crosshatchings of my knuckles. Was it sacrilege to teach Shakespeare and Keats with hands in such a state? Perhaps. But in ways that daily surprise me, I was becoming more and more sensitive to the struts and supporting members of literary creations. Any poem is infinitely more complex than any engine, but going from one to another in the intimate way I was doing proved instructive and enlightening. One did not need to lapse into the breezy generalizations of Robert Pirsig in *Zen and the Art of Motorcycle Maintenance.* Whether one called it zen, logos, or ratio, the inherent discipline of repair work sharpened the hands, the eyes, and the mind, leaving one with a self-sustaining sense of liberation. Once I grasped that fact, my apprenticeship was over, the *rite de passage* was accomplished, and Larry and Buck disappeared forever, leaving me with a car that stayed out of doors during the worst winter in one hundred years. It never failed to start on the first turn of the key.

The experience with Larry and Buck released a whole complex of memories which I had conveniently tucked away or repressed once I entered the rarefied atmosphere of academe. In those sacred precincts automobiles were not a proper subject of discourse, except perhaps as counters in a game of fiscal or economic analysis. And one learned quickly

to drive the right kind of automobile, namely, a foreign one. Preferences varied from one ivory tower to another, but certain makes were always in favor. For the economy-minded, a used Hillman Minx or Morris Minor might be ideal. An MG, old or new, was popular, as was the Mercedes, particularly the diesel-powered models. But the ultimate in academic chic was the Volvo, sold in advertisements as the thinking man's car. And I believed that I shared vicariously in that cool Swedish rationality as long as I owned my Volvo 145 station wagon, despite the fact that the SU carburetors were untunable, that the points wore out every 2,000 miles, or that the camshaft collapsed after 50,000 miles (for which the factory did partially reimburse me). I needn't cite the thrown piston rod from my new Mercedes or the VW Square Back that greeted the front passenger with a cascading waterfall (via the glove compartment) every time it rained. And while my two MG's were delightful to drive, both leaked notoriously, and the electric systems were abysmally inefficient. And I did drive three hundred miles (in a borrowed Plymouth) to buy a fuel pump for the last MG. I had been duped with advertising techniques long since documented by Vance Packard in *The Hidden Persuaders*. When the Volvo left me on a snow-packed road in the middle of January, I vowed to find an American car that most resembled the one I had almost forgotten: my father's pride, a 1950 Chevrolet Deluxe.

That Chevy had been my father's first new car, and I knew it as our family car, as well as the car on which I learned to drive. My first lesson on the correct operation of clutch and brake pedals ended with the destruction of our wooden garage doors and a few flecks of white paint permanently embedded in the front bumper of the Chevy. The car cost $1,800 new in 1950, and except for tires, batteries, brake linings, belts, and hoses never cost another penny. We performed all the work on it right in the driveway, with a few simple tools and the jack as provided by the factory. The car came with a service manual, no radio, and a "lap robe" for chilly evenings. I don't recall ever thinking of it as anything but transportation or work since I held the wrenches, pumped the pedals, or cleaned up the mess while my Father did the interesting jobs. Once a month we checked every fluid, bulb, and belt, changed the oil and greased everything. No one ever touched the car except me or my father. When I inherited it, that old Chevy had 99,000 miles on the odometer. When I sold it five years later, the total was up to 133,000—and I sold it to a service station owner who used it to haul wrecks and boost batteries on cold winter mornings. The luminous days with Larry and Buck have allowed me to relive these days from the past, and perhaps the restoration of the '58 Bel Air was a strange way of reclaiming the lost '50 Deluxe. Sometimes I would be driving late at night across the prairie during the dead of winter. The world had turned glacial; time and distance melted into one another. The radio cracked and

fizzed as station signals faded in and out from all over the country: WABC (New York)...WSM (Nashville)...WLS (Chicago)...WWL (New Orleans). The wheel vibrated ever so slightly through my thick gloves, and for an instant this car was every car I had ever owned. I thought of grandfather's Model A, bought new in 1929 and kept running for twenty-five years. The thing rocked and pitched like a buckboard through the cotton fields. The roof was kept tight with yearly applications of tar. It came to be a part of him, like a horse or mule. I half expect to find it one of these days, waiting at the edge of a green pasture, where he left it over twenty-five years ago.

All this telescoping of time and distance seems especially ironic since the American automobile is the supreme example of planned obsolescence in the world's largest consumer economy. What had been designed as a piece of ephemera, something to be forgotten as soon as the annual models appeared, became a species of time travel: we found ourselves going backward in time while moving forward in space. Aristotle was deprived of the opportunity to define the exact nature of the automobile, but I suspect that with his keen concern for causation and movement generally, he might look at the automobile as the art of movement in the machine age. In *The Poetics* Aristotle described the plot or mainspring of action in a play with the Greek word *dunamos* (English "dynamic"). Perhaps we have thought of automotive dynamics in rather narrow and unimaginative ways. The term "dynamics" is a staple in the critical vocabulary of disciplines as diverse as engineering, psychology, and aesthetics. In ways not yet fully understood, the automobile belongs in all three areas of inquiry. As such, it represents a nexus of many skills and undertakings.

Precisely because the automobile can be viewed from so many different perspectives, it possesses an unusually high visibility within American culture. Automobiles are probably the most recognizable and identifiable artifacts shared by most Americans. Literary critics might call this charismatic power "resonance," while an anthropologist might see the auto as our source of mana. But the copywriters seized upon and enhanced this mythic potency almost from the outset. Here is a representative sample from a 1951 Ford advertisement:

> Today the American Road has no end: The road that went nowhere now goes everywhere.... The wheels move endlessly, always moving, always forward—and always lengthening the American Road. On that road the nation is steadily traveling beyond the troubles of this century, constantly heading toward finer tomorrows. The American Road is paved with hope.

It isn't the Ford as such that is being sold here but a sort of Whitmanesque dream of the future. In an analogous way, the central importance of the

The Zen of Truck Repair

My infernal desires to tinker and improvise met their nemesis in the physical form of a 1974 Chevrolet C-10 Truck, the most rust-prone vehicle in the history of General Motors, produced in a model year that marked the industry's first serious attempt at dealing with pollution and excessive fuel consumption. As a rule, those 74's tended to stall, wheeze, and lag since the engineers had set up carburetors and manifolds for the cleanest exhaust possible, sacrificing performance in the process. And in spite of these alterations, they still burned gas as if OPEC had never existed. "Gas hog and rust bucket," summarized Sheldon, one of my rural mechanic friends.

Yet this orange behemoth represented an upscale purchase for me when I bought it in 1981, trading in my museum-piece, an even older 1966 Chevrolet C-10, with explosive valves, poor brakes, and a shift that stuck perversely in first gear at the most inconvenient moments. For $700 I drove away with what seemed to me a pretty classy truck—it had a comfortable seat, a working radio, and a rather manageable turning circle. On the other hand, its color ("Grecian Bronze") nearly duplicated the ugly orange of Highway Department vehicles, school busses, taxi cabs, and the utility trucks of the power companies. The right vent window was missing entirely and had been replaced with a crudely sawed triangle of plywood, affixed with strips of silvery duct tape. The previous owner had covered the windows and bumpers with stickers of the "America: Love It or Leave It" and "Grass or Ass—Nobody Rides for Free" variety. He had covered the floor with the world's shaggiest carpet (in shocking pink), and I naturally assumed that huge fuzzy dice in matching tones once dangled proudly from the rear-view mirror (itself in need of repair).

A purist in these matters, I sought to remove all these trashy gee-gaws from *my* truck, and I began to haunt junk-yards (or "salvage companies," as they like to style themselves) in Decatur, Springfield, and Effingham— and in rural backwaters of Macon and Shelby Counties. These places constitute the greatest open-air museums in America, with their jagged

heaps of multi-colored trunks and hoods, row upon row of old and mysterious vehicles with doors ajar and bodies resting in bizarre postures on springs and axles, grotesque stacks of tires, and thousands of hubcaps and wheelcovers hanging from pegs and nails in the rickety sheds that serve as "offices." I became a superb scavenger, pacing over the curious soil of these places (a new geological medium of Illinois black dirt, paint flecks, rust, powdered glass, screws, washers, rivets, and oddly twisted bits of wire). Typically, I was looking desperately for such items as rubber clutch- and brake-pedal pads, a left vent window with locking mechanism, a windshield washer pump, or seat belts (Rambo had removed them before selling the truck). Strangely, one of the hardest items to obtain was a matching set of wheel covers. I rode around for years with a mismatched set until I finally located a perfect set on a wrecked 1976 Chevrolet Suburban resting peacefully on a hill side in eastern Shelby County. A bit of dickering (a skill I mastered during my junk-yard days), and the four silvery discs were mine.

All these Grail-like quests ended in the acquisition of physical objects, hard and well-defined things like a distributor or water-pump. But the most important acquisitions were all psychological. At times, I wondered if I were rebuilding the truck, or if the truck were rebuilding *me*. For I had decided to Come Out of the Closet with this truck. My old blue and white 1966 junker had been my "country" truck, entirely suitable for fishing and hauling wood. It had spoiled me with the horizon-wide vistas of its big truck windshield and the rock-like stability of moving a heavy object swiftly over the landscape. I had shied away, however, from parking it in the Faculty Lot at the little college where I taught writing and literature. For as soon as I began commuting with the orange machine, I became "Farmer Dan, the Truckin' Man" to one of my more obnoxious colleagues, and no fewer than *four* others inquired when I was going to install a gun-rack. Appearances count mightily in such close quarters, as I recognized when one of the administrators pulled me aside, and, in leaden-eyed seriousness, whispered, "Don't you know professors aren't *supposed* to drive a truck?" I expect he also believed that women should remain housewives and blacks should "stay in their place." It just so happened that on that very day I had been teaching Henry David Thoreau's *Walden*, arguing with my students that old Henry had every right to camp by the pond if he chose to do so. "What good is democracy if we can't use it?" I challenged. And if Henry could have his shack, then I could have my truck. I made a point, especially at the most elegant functions, to arrive in my truck. The new Impala stayed home; this was war.

Other twists and tilts occurred. One of my best students, who had grown up on a farm north of Peoria, spied me driving up in my truck, sprinted over, and shook my hand. "I always liked you as a teacher," he

blurted, "but now I know you're *real*. I just can't believe you own a truck!" Maintenance personnel who had hitherto been polite suddenly became friendly, and this trend became more and more pronounced as I began the long and bizarre process of restoration. One of the basic Zen principles is that anything can become its opposite—and usually does. The truck could function as barrier or passport, and it all depended on point of view. Consciously or unconsciously I was testing myself and everyone I knew with this 3,600-pound instrument produced by General Motors. One of my artist friends, familiar with my weakness for these vehicles, commented: "This is the most *middle-class looking* of all your trucks I've seen." Another friend, a literary critic and philosopher by trade, who was himself engaged in restoring a 1951 GMC truck, growled, "I thought you said this was an *old* truck!" And a certain bespectacled editor of a Central Illinois alternative newspaper once entered the machine without breaking stride or losing the thread of conversation, thus passing his test with flying colors. The ultimate twist came last year when I began reading articles in the weekly magazines that trucks had become extremely popular vehicles— especially among Yuppies. The hidebound culture had performed another one of its inevitable flip-flops.

When I was in college, my philosophy teacher specialized in ontology, which might be described as the theory of identity. His favorite example was that of the sock that had been darned so many times that not a single thread of the original remained, even though the precise *form* of the sock persisted. I thought of the sock often as I tried to re-create this truck, not just as a social statement but as an aesthetic affirmation. For me, an improperly functioning object was the ugliest thing of all (I know Frank Lloyd Wright would surely agree), and my greatest challenge was replacing the *internal parts* of the vehicle. By luck, I mentioned my dilemma to my friend Ed at Ed's Automotive Service in Decatur. I had once watched Ed as he repaired a faulty gas gauge in a Chevrolet Nova I owned. He disassembled the entire dash and instrument panel, traced every wire from dash to gas tank, removed the tank, and finally located the problem in the floater mechanism which communicated the level of fuel in the tank to the "pointer" on the gas gauge. I had seen five other mechanics give up in despair on this job, but Ed took it step by step, with the methodical coolness of a true craftsman.

Ed discouraged me from buying any of the used engines we found at area and regional junkyards because of potentially hazardous manifolds and engine heads (the top part of the engine). For weeks we called around, sent out notices, and generally drew a blank. Then one day Ed learned of an engine in Decatur that was being re-shipped to the factory because the buyer balked at the price ($1,300); however, the engine was a bargain since it was brand-new and came directly from the Chevrolet

factory, not from a rebuilder. Besides, this engine arrived complete with manifold, water pump, and distributor ("extras" which usually had to be purchased separately). At the same time, Ed replaced the clutch which had expired a few blocks from his garage—and which was the original cause of my visit. As Ed pointed out, the truck had given 124,000 honest miles of service (64,000 of which were mine), not a bad record for a regular production-line vehicle that had endured the tender mercies of its first (macho) owner. Rambo apparently never changed the oil (it consumed a quart on nearly every outing) and double-clutched or drag-raced at every opportunity. I expect to get 200,000 miles (or more) from the vehicle, a reasonable expectation since the odometer now reads 171,000 miles, and the sheet metal is shiny and new. But I am getting ahead of myself.

For I now faced a new dilemma, just as in "real" life: the mechanically new truck was cosmetically repulsive. I drove it for a year and continued with other hidden improvements (re-cored radiator, rebuilt alternator, rebuilt master cylinder, new brakes, radial tires, FM radio, front springs, shock absorbers, ball joints, one seat spring, seat covers, and headlamps). But nearly every day a piece of the body would literally flake off, and one morning a chunk of the door fell off, and my daughter's foot went through the door sill. Clearly, it was time for major improvements. The Chevrolet dealer balked, pulled out a parts catalog, and showed me the "exploded" drawings of the truck that illustrated all the parts (panels, fenders, etc.) that I would need. He estimated $4,000 for parts alone, not counting painting and installation. I tried several other dealers and auto body shops; most laughed. All were discouraging, and no one wanted the job. On my own, I tried to find new doors and especially a new bed, but most rust-ridden 74's had been pulverized into scrap, and the few good ones could not be separated from their owner's clutches.

If I had not passionately believed in the inherent beauty of the thing, I suppose I would have quit at that point. Somehow I had come to see my truck and its squarish lineaments as part of the order of life on the prairie, a simple, functional, and unpretentious thing, like a barn or a silo. The ancient Greeks admired proportion and harmony, and *any* truck is a kind of harmonious arrangement of three boxes in a rough mathematical relationship of 2:3:6 (hood, cab, and bed). And as I repaired and tinkered and worried over the old thing becoming a new thing, I thought of myself and how much I had changed since 1974, especially in eating habits, social philosophy, bodily appearance, and dress. I certainly ingested far less salt, sugar, and cholesterol. I wore glasses now and worried about everything. Some of my quarter-panels were in need of repair, yet my dynamo still charged me up on a daily basis. Were we going together, this truck and I, always moving but never quite the same from milestone to milestone? If the truck was part of my life and livelihood, then keeping it going was the

same as keeping myself going. Getting up every morning was the real challenge; everything thereafter (including truck repair) was relatively easy.

A small 3 X 5 notecard announced Jerry's body shop business on a bulletin board at a tire dealership in Shelbyville. I called Jerry, received directions, and followed a back road out of Shelbyville to a part of Shelby County that more closely resembled Tennessee or Kentucky. Jerry's shop was a big metal barn with concrete floor set in a flat place in front of a line of gently rolling hills. There was deep snow the morning I visited him, and we picked off pieces of rust as we scrutinized the truck. Jerry was hesitant: "Basically, we're going to make a new truck," he mused. I explained that was precisely my intention. He said he'd have to think about it because two huge technical problems loomed before us: (1) where to find a *short-bed,* the rarest of the already rare 74's, and (2) how to estimate costs if the *frame* beneath the rusted body was bent out of alignment (it wasn't, we later discovered). The next week he called; somehow "a friend" (there were many such friends, part of an informal, underground network) had found a short-bed Chevy, wrecked in front but otherwise useable. Jerry took the job for $2,700—a lot of money for an old truck but a small sum for the consummate craftsmanship I received.

Each time I visited Jerry (usually on weekends) I would see another example of his workmanship: a newish Dodge truck sprayed with baby-blue lacquer. Looking into the finish was like looking into deep water. "Run your hand over it," Jerry encouraged. It was smooth as glass. "I do good work," Jerry observed in a statement that might have sounded like bragging but was actually understatement, especially as regards his work on a black- lacquered '63 Nova. Jerry had graduated from a special painting school run by General Motors; he received $35 an hour for his work in the paint department of a well-known Chevrolet dealer. I thought I was getting a bargain at $17 because Jerry only took jobs he *enjoyed.* Most of the money went for paint, materials, and electricity. Essentially, Jerry kidnapped my truck for three months (we had to re-charge the battery when it finally left his shop in early spring). If Jerry found additional parts (like a hood emblem), he added them for free. The white pin stripes were his idea, too, and now I can't imagine the truck without the demure little line flowing down its flanks. An utter perfectionist, Jerry re-positioned the new doors five times before he felt they were acceptable. My old drafty truck was now so airtight I had to *slam* the doors shut.

I joined part of Jerry's family of customers. There were others, like me, who would show up on weekends to help (mostly lifting, cleaning up, and masking), or just to watch. I loved to watch Jerry work. A little guy with beetling eyebrows and a shock of broom-like black hair, he would heft huge body parts as if they were made of paper. He *saw through* every car and

107

interpreted it as a series of seams and welds. He made magic in his shop, as on the day when he installed cab corners and rocker panels on my truck, sawing off the rusty portions, welding on the shiny new parts, and grinding the joints down in showers of blue metallic sparks until old and new were (once more) indistinguishable. I watched the truck literally go to pieces and slowly come together piece by piece (new doors, one new fender, used bed, used tailgate, used hood). I thought of the philosophy class and the sock again—which truck was this now? Was it even the same truck? At one point, the truck boasted six different colors (red, orange, black, green, blue, and white). At each stage in the process, Jerry would have to wrap (or mask) one part of the truck while he was painting another. The highly conceptual nature of restoration hit me again and again as I saw my truck assume one new form (or deformation) after another, not unlike the "wrapped" pieces of sculpture by the artist Christo. When I last saw the old truck, it consisted of a rusty pile of doors and fenders unceremoniously dumped on the rubbish heap. Out of the old springs the new, and art is the process of making unity from diversity. When Jerry was finished, my truck glowed a beautiful deep red, the standard red used on all 1974 Chevrolet trucks. The very shape of the truck—or at least my *perception* of the shape—was different. It didn't seem like the same truck. "It's all in the color," observed Jerry as he picked up his tools.

Then came the zen of re-adjustment. I feared stone chips, bumpers, car doors, and splattering insects that might damage this pristine crimson surface. Gradually, tentatively, I began by hauling two-by-fours, firewood, two loads of gravel, and one of sand. The truck survived, and a new cycle began as surely as the old one had ended. But I'm not kidding myself. All these warped perceptions of newness and oldness have left me strangely passive—or at least tolerant. No matter how hard I try, the truck will never be totally new again. Lights, wiper blades, and even the shift linkage have gone out since Jerry worked his wonders. And they have been replaced, without much thought or fanfare. Yet last week, at two degrees below zero, the engine cranked right up, I dug the vehicle out of a snowdrift, and set off nimbly for work, listening to National Public Radio's *Morning Edition*. I counted four cars in the ditch as I made my way over the familiar but ice-packed route.

A few weeks earlier, I had been re-reading Robert Pirsig's *Zen and the Art of Motorcycle Maintenance*, and I was enchanted once again by his splendid line, "The machine you are working on is yourself." I wanted to share that idea with Jerry, show him my new floor shift, and let him drive the truck now that the carburetor was finely adjusted (and the gas mileage was up to 18 miles per gallon, which is better than many "new" trucks). Yet when I arrived, the shop was closed, and the place looked sad and deserted—even Jerry's house trailer, set up next to the shop, was gone. A

small flock of crows landed in the cornfield across the road, and a light snow began to fall. The truck, I suddenly realized, had never looked more beautiful.

A Sense of Place

A beaming usher opened the massive doors to the Old State Capitol and politely suggested that I "look around" before the beginning of the premiere performance of *Portrait of a Prairie Capitol*, another "living history dramatization" by the Great American People Show. So I dutifully soaked up the ambiance of that old and curious building with its vaulting central hallway flanked by special rooms on either side. I noted the manuscript copy of *The Gettysburg Address* in its hermetically sealed container (an appropriate safeguard on this oppressively muggy June night), the lithograph of Andersonville Prison "drawn from memory" by one Thomas O'Dea, the wood-burning stoves with their crinkled flues, the marble statue of Stephen A. Douglas (the "Little Giant"), the small brass cannon under the stairs, and the ubiquitous plumes, inkwells, and leather-bound books of long gone legislators. I was glad I followed the usher's advice because *Portrait of a Prairie Capitol* is an unusually effective dramatization of this very building, an evocative art work with an eerie, reflexive quality. The production turns on itself because the dramatized events actually took place in the Hall of Representatives where the audience sits and where the three actors and fourteen musicians perform passionately.

A few words are in order here concerning the unusual form of this production. *Portrait of a Prairie Capitol* is neither a dramatic reading nor a musical suite (although it contains elements of both), and it is certainly not an "outdoor historical drama" like the justly popular trilogy (*Your Obedient Servant, A. Lincoln; Abraham Lincoln Walks at Night;* and *Even We Here*) produced by this same company at New Salem State Park. The three narratives of *Portrait of a Prairie Capitol* most resemble the chorus of classical Greek dramas—individuals who singly or collectively provide the audience with critical background information. But here background and foreground tend to blend together beautifully since the presentation is about and in the Hall of Representatives which Lincoln helped to establish by leading the "Long Nine" in their campaign to move the state capital from Vandalia to Springfield. In this same Hall of Representatives "church

services, social functions, chess, banter, and gossip" occurred; Ralph Waldo Emerson spoke here; and Lincoln delivered a eulogy for Henry Clay here as well as his famous "House Divided" speech. Finally, on May 3, 1865, the funeral train carrying Lincoln's body arrived in Springfield, and Lincoln was laid in state: "And in this, this room the body lay." At that moment I experienced what the French call a *frisson,* an authentic shiver of delight and recognition—all the more remarkable on a warm and humid night.

The music for *Portrait of a Prairie Capitol* was composed by Tim Schirmer who for the past eleven years has served as either composer or musical director for the Great American People Show's production at New Salem. Mr. Schirmer's music for *Portrait* is fresh and innovative, at times recalling Stravinsky or Copland, always highly charged and compelling. The opening pages of the score feature haunting passages by oboe and trombone, followed by intentionally discordant horns, all punctuated by the plucky xylophone of Mary Watts. These opening passages constitute a sort of hymn to the earth and land, a musical expression of the "prairie ocean" and the territorial era when there were "less than two white inhabitants per square mile." Later the "golden earth stone" (some of it dredged from Lake Springfield) was turned into the State Capitol, following the architectural plans drawn by John Rague, a local resident who won a $300 prize for the best design. Soon the building went up, and Lincoln began to try the 200 cases he would ultimately argue here (winning about half of them). On a less lofty note, this was also a time when there were "hogs in the streets of Springfield...mud and hogs ruled the Capital City." So this old stony landmark is truly an edifice of "conflict and celebration" and the performers conclude by reminding us that "Lincoln's suffering was also our own." Lincoln, after all, sought "peace among ourselves and with all nations." Personally, I couldn't help thinking about Lincoln's reaction—if he were still here—to apartheid and military aid to the Contras, among other important issues of the day.

It's impossible to sit through this dynamic forty-minute presentation without coming to terms with Lincoln. The Old State Capitol building becomes wonderfully real and highly symbolic all at the same time, and that kind of effect is the mark of powerful dramatic art. Much of the credit for this effect goes to the three narrators who position themselves at strategic places all over the Hall of Representatives (including the balcony), delivering their lines with a mixture of conviction and awe, passion, and tenderness. Tom Tobell possesses an unusually clean and bell-like voice. Steve Jenson has an intoxicating, musical lilt to his voice, and Rose Ahart projects her voice powerfully and resonantly throughout. Rose Ahart and her husband John are co-authors of the text, and John is perhaps the pivotal member of the Great American People Show since he

is author of two of the New Salem productions (*Your Obedient Servant, A. Lincoln* and *Even We Here*).

At the end of the special opening night production, Michael J. Devine, Director of the Illinois Historic Preservation Agency, stepped forward and acknowledged the presence of several legislators in the audience; then he introduced Robert Klaus (Director of the Illinois Humanities Council) and John Ahart (who, in turn, introduced Tim Schirmer and Rose Ahart). *Portrait of a Prairie Capitol* is the happy result of inter-agency cooperation. It was sponsored by the Illinois Historic Preservation Agency and the Illinois State Historical Society, and funded in part by the Illinois Humanities Council. Sophocles and Shakespeare, among others, recognized that a state without a sense of its past has no real claim to its future. There has been much talk lately of building roads in Illinois, but for my money it is only through the evocative medium of art and dramatic productions like *Portrait of a Prairie Capitol* that we can truly "Build Illinois."

The Wonder of Windmills

Rural folk used to grow up with the music of windmills, and in the background of their lives there was always the silky sound of free-spinning blades, the ratchety noise of worn gears, and the unmistakable thunk and scrape of the head and tail as they pitched and yawed into the wind. The proud tail flew like a stiff, metallic flag, always set at an oblique angle to the revolving blades, governing the speed of the whole contraption from a gentle whirring in light breezes to roaring revolutions in storms and gales. As long as the wind was blowing, one heard the reassuring gasp of the water pump at ground level, sucking up cool well water to sustain the livestock, the garden, and the family itself.

In good weather, at least, windmills often became the focal point of farm life. Party lights and birthday decorations sometimes dangled from their steel wooden towers. Children played tag beneath them, and at least one farm wife remembers comforting a colicky baby beneath the soothing sound of the windmill—or sitting under its shadow of a cool evening, shucking sweet corn and snapping green beans. In Amish country, especially, the concrete platforms on which the windmills are mounted are often planted with colorful borders of pinks, petunias, pansies, and marigolds.

From the Civil War era to the end of World War Two, windmills dominated the horizon, in the company of a few other typical Illinois icons: silver-capped silos, white church steeples, and boxy red barns. Although the first truly American windmills appeared in Wisconsin and Connecticut, Illinois quickly became the leading state in the adoption and manufacturing of windmills; in fact, by 1880, the state of Illinois dominated the windmill trade. The two most famous brands to come out of Illinois were the Halladay (manufactured in Batavia, Illinois) and the Aermotor (made in Chicago), although the Sears and Roebuck company sold a very reliable and inexpensive model that saved many family farms during the dusty years of 1934 and 1936.

Homemade windmills occurred less frequently in Illinois than in other prairie states, like Nebraska, where they proliferated along the Platte River. Any farmhand who happened to be mechanically inclined and who could lay his hands on a working pump, a straight shaft, a set of reduction gears, and some spare lumber or sheet metal, could—and sometimes did— produce a totally functional windmill. Factory-bought mills were often a matter of backwoods chic and Keeping Up With the Joneses. But by 1950, the windmill in Illinois was largely a matter of nostalgia (although a very powerful form of it), for the old clanking blades and vanes that once powered a rusty pump had now been replaced by municipal and county water systems and by the ubiquitous electric pump. Today only five percent of the farms in Illinois boast of a working windmill, and only about *one percent* of the farms use the windmill exclusively. Most of the old trestles and towers have been torn down and carted away.

Yet it is remarkable how many of the old mills survive, many of them potentially restorable. It is sad to see a wrecked windmill tower with a crushed or broken head, and sadly I see many in rural Shelby County where I reside. Saddest of all, perhaps, is the once-proud windmill that now serves a lowly role as bearer of an ugly TV antenna. But many windmills are kept in the family (even if the gears have ceased to function), and some farmers will plow wide arcs around the rusty old towers that stand solitary in a field of wheat or beans, festooned, as they often are, with trumpet vine and wild morning glory. Equally remarkable are the thousands of ornamental windmills to be found in Illinois, often constructed from the parts of once-working mills (or more recently assembled from widely available kits). It is still possible to find windmill jacks and mechanics (although they are a rare and virtually extinct sub-species of *homo sapiens*), and one may even purchase spare windmill parts from such companies as Heller-Aller of Napoleon, Ohio (and even Aermotor parts are available from a distributor in Broken Arrow, Oklahoma.

The story of windmills on the prairie is only one small (but exciting) chapter in the larger saga of windmills and human civilization. One might even argue that farming and the agricultural revolution, which gave birth to the first high cultures in the Fertile Cresecent, could not have been sustained without the power of windmills (or wind-engines, as they are sometimes called). For around 200 years *before* the birth of Christ, windmills were already a familiar feature in ancient Persia, and they spread rapidly throughout the world, assisted by Genghis Khan (who kidnaped windmill mechanics) and the rise of Islam (which brought windmills to the doorstep of Europe). By the year 1100 A.D., windmills became fairly common in southern Europe, and by the time of Shakespeare (1564-1616) windmills had become so numerous that Cervantes could depict Don Quixote tilting at them in a symbolic gesture of futility. Holland

literally owes its existence to windmills, which drained the seaside marshes and swamps (or *polders,* as they are known), thus creating dry land.

The windmill has properly become the national symbol of Holland, and the Dutch have always treated them with great respect, giving them pet names and even dressing them up on festival days. The Dutch perfected—and named—many different kinds of windmills, including those which were mounted on a post and the more familiar kind which consisted of a round or octagonal building surmounted by a cap and four, sail-like blades. Even the *position* of the blades served as a kind of semaphore or code, and such secret messages were relayed during the Nazi occupation of Holland. In 1850, Holland alone had over 10,000 windmills. Now there are only a few, and they are guarded as national treasures.

Of course, windmills were also plentiful in Denmark, England, Spain, and Greece (where they usually sport a thatch roof and tiny triangular sails mounted on a stick-like wheel). The Dutch naturally brought their windmills to New Amsterdam (Manhattan), and the sturdy mills remained long after their builders had disappeared. Along the East coast, windmills were used primarily in manufacturing applications (grinding grain or sawing wood) or in the simple pumping of sea water to produce a brine that eventually became valuable table salt. What we think of as a typical windmill today (often called a "farm" windmill) is the result of some happy tinkering performed in 1854 by a Connecticut mechanic named Daniel Halladay at his shop in Ellington, Connecticut. By 1866 his company was doing a brisk business out of Batavia, Illinois, and the windmill boom was on.

Like all typical American productions (the Colt revolver, the Model-T Ford, for example), the Halladay wind-engine was light, flexible, practical, and relied on interchangeable parts. A farmer living in western Pennsylvania, say, could buy an American windmill, throw the pieces in the back of a wagon, and re-assemble them two weeks later somewhere on the vast grassland of western South Dakota. So the windmill of Halladay's basic design dominated the prairie, the high plains, and ultimately the far west. During the twenties and thirties, wind-engines also functioned as wind- turbines or *wind-generators.* Thus, before the advent of the Rural Electrification Act, farm families enjoyed appliances and lighting from simple arrangements utilizing wind-engines and storage batteries.

So the topic of windmills has become strangely relevant again, at a time when self-sufficiency in energy seems to be a most desirable national priority. During World War Two an M.I.T. graduate named Palmer Putnam built an immense wind turbine on Grandpa's Knob in the Green Mountains west of Rutland, Vermont. Many valuable data were gathered before this essentially experimental machine was dismantled, thus paving

the way for recent wind-turbines like the one at Plum Brook, Ohio, co-sponsored by the National Aeronautics and Space Administration and the National Science Foundation. NASA also funded a strange, egg-beater-shaped windmill at its Langley Research Center in Hampton, Virginia.

Most of the interesting work on wind-powered turbines has occurred in France, Denmark, and Sweden. But wind-power has attracted many followers in this country, especially following the oil embargo of 1979, and all sorts of scenarios for the future have appeared in which wind-power, solar- power, and geo-thermal energy are the primary components. One wonders why the Federal Government has failed to follow through. Could it be that oil and coal (whether domestic or imported) can be taxed, while the wind remains forever free? Private initiative will undoubtedly have to pave the way (considering the Government's foot-dragging on AIDS research, wind- power hardly seems a high priority in the final days of a failing administration). In any event, Carter Wind Systems, Inc. (Route 1, Box 405-A, Burkburnett, Texas 76354) will provide literature on do-it-yourself wind-turbines. I was immensely pleased that one of my virtual neighbors, Jim Macari (of rural Shelbyville) had erected a wind generator atop a huge tower. The thing resembled a big white propeller with no airplane behind it, and it dominated the sky near Coon Creek. According to Mrs. Macari, the generator provided ample electricity for winter and spring use, but the winds were too slack and the demands of air-condition-ing too high for it to cope with summer use. I also took pleasure in the old farm windmill still standing in their flower garden, as if some of the spirit of the old mill was passing into the new.

You needn't be an ecology freak or a nature mystic in the manner of Rudolph Steiner or Carl Jung to appreciate the elemental beauty of windmills, the way they link the sky and land, the way they combine the elements (air, earth, water), all the while using the archetypal forms of circle, square, triangle, and pyramid. One derives such deep pleasure from these old things, and sometimes that is enough, more than enough. Forrest Wardall of rural Pana climbed the tower of his old Sears and Roebuck wheel (erected in 1934, although an earlier wheel stood on the same spot since 1900), all the while reiniscing about the fabled wheels of old with names like Champion, Star, and Challenger. He told the story of how the well beneath this mill filled with water spontaneously on the day it was dug— exactly as predicted by the "water-witcher" who used his peach-stick wand to find this unassuming spot that kept giving water in the droughts of the dustbowl, long after other wells had turned stone dry.

Henry Kuhns, a genial Amish farmer and windmill mechanic, concurred with Wardall on the power of water-witchers, although he balked at the term "witch." Henry felt it was "all a matter of electricity." Henry clearly felt the peach stick was something of an affectation,

personally preferring to make use of a piece of wire, which could be wielded antenna-style. He introduced me to John Stutzman, an Amish grain dealer, and proud owner of a fully operational Aermotor, which pumps its pure water into a giant redwood holding tank encased in a concrete tower. I stood in the cool darkness under the tank, inhaling the dampness and the wonderful smell of old wood.

If windmills really *do* bring all the elements together, I felt that power surge peacefully over me as I emerged into the brilliant sunlight to see my nine-year-old daughter riding bareback on Red, John's twenty-one- year old pet pony. A large collie named Caramel appeared and began licking my hand. I followed John into the house to see a litter of day-old Boston terrier pups, visibly swelling as they suckled. I was unusually conscious of smells—dog hair, milk, wood, straw, manure, corn pollen, dust. I felt the old and the new as I had never felt them before, and somehow they were all folded in the rusty music of the windmill. In the near-darkness, Caramel followed us out to the car, and I thought of Harold Orvis (Forrest Wardall's neighbor) summing up everything I had learned about the windmill:

"We just heard it singing, singing all through the night."

Construction/Deconstruction

Last summer I was stunned by the other-worldly nature of home repairs when, after weeks of hot work on my front porch (insulation, flooring, walls, ceiling, roofing shingles, windows, steps, storm door), I collapsed one evening in the kind of half-stupor that follows a full day of measuring, sawing, and hammering. Suddenly, I experienced a strange rush of delight in the unpromising sight of nails and screws! My living and dining room had long lost their once-civilized character, having gradually been transformed into woodshed, tool room, and workshop. There, on the sawdust-tracked carpet, in the natural order of their use and application, each in its proper bag or box, lay the little fasteners that utterly dominated my consciousness: tiny silver brads and coal-black tacks, stove-black box nails, skinny panel nails (hickory, sand, and white), cement-coated construction nails in 8-, 10-, and 16-penny denominations, stout and spikey masonry nails, and the long twisted deck nails with spiral designs running up and down their sides like old-time barber poles. At age forty- four I had discovered the rare beauty of ordinary nails and the intensely personal dialogue that occurs with the tools of our trade. E. B. White once said that there was no greater pleasure than sawing a perfectly straight line on a clear pine board. Now I understood precisely what he meant.

For seven incredibly hot weeks when the mercury regularly rose to 103 degrees Fahrenheit, including the day that it ascended to 108 degrees on the big thermometer in front of the Standard station (the one instrument by which my whole rural village monitors the quality of day-to-day life), I toiled. I sweat as I had never sweat in my entire life on this planet: my consumption of tea, diet Coke, iced water, and apple juice started off at around one gallon per day. By the end of the summer I was easily chugging down three gallons a day, working in baseball cap, gym shorts, and a ruined pair of Sperry Top-Siders. By 9:30 I would be soaked, and I would remain that way for the next twelve or thirteen hours. At one point it was so hellishly hot that my feet slid on the freshly-laid tar paper of my steeply canted roof, and a bundle of shingles melted in my arms as if they were chocolate wafers. For every step forward, there were at least two or three backwards. Even the good days were followed by unspeakable back

pains, blisters, and minor abrasions. There is no construction without deconstruction. Only beginners think otherwise.

I began by "deconstructing" my 93-year-old porch, which meant removing the ceiling, composed of narrow tongue-and-groove boards (now warped and encrusted with disgusting layers of old lead-based paint). The nails were so ancient that they had rusted into the rafters and joists. Each plank stubbornly refused to yield, contorting itself into a bow-like shape until it finally snapped loose, smacking one of my upper body parts and liberally depositing soot, dirt, and mouse-droppings all over my head and face. In like manner, the ancient skirting around the foundation required the vigorous application of two pry bars and an oversized crow bar before it broke loose with an audible *whack*, leaving me with a deeply lacerated shin which (naturally) bled on the next day's clean lumber.

And the summer wore on, each day as monotonously enervating as the one before. Dry patches appeared all over my once-lush yard; the roses withered. The "porch project," which I had meticulously planned to finish in two weeks, dragged on to four, five, and, ultimately seven weeks. My wife has long delighted in doubling my estimated time to arrive at the actual length of the project; this time we were both wrong.

But we were also right in the curious anti-logic of these undertakings. We found a new order and lightness in our lives. We had decided to help one another in this job so that we could go back to our "regular" work. The porch *became* our work, and everything else (watering the garden, shopping, cooking, doing the laundry, even reading in those few blissful moments before utter exhaustion set in) was subordinated to the hot spot at the front of our house. Deconstruction means construction, too. I built the porch, I put up a new roof, I installed four windows, re-wired a porch light, and hung a door. But what I really built was another version of myself. I had vowed to take the time, for once in my life, to do a job right, to give it proper time, to spare no effort and no cost (my original estimate was 65% shy of the real cost), and to derive deep pleasure from utterly physical work.

I began each day without rancor or enthusiasm; I developed a kind of lightness I had never known. After a month, I could sink big nails in tough pine with a few perfectly balanced strokes. I could estimate distances—inches and feet—down to an eighth of an inch. I learned to scale a roof, balance impossibly awkward surfaces, and design solutions for problems that never occurred in the cool confines of my university.

Now is the time to talk about car siding, because everything I did on the porch came back to car siding. I had always loved this beautiful, slightly knotty fir with a protrusion (tongue) on one edge and a hollow depression (groove) on the other, bisected by a shallow line (or bead) in the center. The virtues of these 8-inch-wide planks were several: ease of manipulation,

naturalness of effect (I finished them with clear polyurethane and no stain of any kind), and weather-tight insulation when all the tongues are properly aligned in their grooves (perhaps I should rephrase that). The first problem I encountered is that, although all the big lumber yards (including one whose name rhymes with *burrow* and another whose name rhymes with *hicks*) stocked car siding, no one carried it in sufficient quantity. I spent two days scouring half a dozen yards only to net about 75 eight-foot-long boards—enough to do the ceiling and perhaps the narrowest wall (but only on the inside).

My most fateful decision was to decide on a 100% coverage with car siding because I liked its strength and integrity. Finally, I found a lumber yard in Shelbyville abundantly stocked with the stuff at prices ($3.50 per eight-foot board) at least a dollar cheaper than big yards in Champaign, Decatur, or Springfield—and this material was straight and reasonably clear without chips or splits. My essential problem for the next three weeks consisted of aligning those miserable tongues into those shy little grooves as I stretched this material over the (still) uneven surfaces of my old porch.

On the PBS program *This Old House,* one of the commentators once remarked that cracks and uneven surfaces give an old house "character." If that is so, then my old house has character enough to fill a triple-decker Victorian novel! No matter how hard I tried, the floor (new joists, new underlayment, and Armstrong self-sticking "wood look" tile) was never perfectly level; the corner of the porch could never be squared (even with my huge carpenter's square and dangling plumb line). So tongues and grooves were perpetually at odds with one another. Construction became deconstruction as I *plotted* and *campaigned* to install every blasted board. Yet they appeared so beautiful once they were in place, and I never lost heart, not even once. My wife and I grew closer, rediscovering some of the mutuality that had brought us together in the first place; we celebrated our twentieth wedding anniversary shortly after the porch was finished. We luckily rediscovered the old joys of working together, in perfect sync, anticipating the other's needs, reassuring and supporting each other (both physically *and* psychologically).

Consider, for example, my ultimate moment of construction / deconstruction—a Sunday afternoon in late July when the first rain in nearly three months fell upon our roof, a torrential downpour that lasted perhaps thirty minutes. At this point I had no intention of climbing on dangerous rafters and installing a new roof, something I had never done before. I was casually installing the last pieces of molding and adding other finishing touches on the inside of the porch when an ominous *drip* began, ultimately leaving a big pool of water on the new floor. I wanted to weep. Clearly, a new roof would have to be installed. My wife supported me, but the next day I supported *her* as we began to remove the first of *five* layers

of old shingles on the roof, using crowbars, shovels, knives, and hammers. All day long ugly clouds loomed, and I silently offered litanies to the heavens, begging for a respite. We installed the new sheathing by the light of the moon, and for the next week we waited for the few cool moments after dawn and before sunset when a few more rows of new shingles could be nailed down. There is a lovely geometry in roofing shingles, as in all the lines and grooves that go into such a job. I felt solidarity with roofers and carpenters everywhere.

I became something of a public figure in our village, since day after day, I was ripping lumber in my front yard, sawing, hammering, or hanging by a homemade scaffold to some inaccessible part of the roof. Neighbors and strangers began walking by every evening to chart the progress, offer encouragement, and (on rare occasions) send up the sweet valentine of rural praise: "She's sure lookin' good." One morning as I was tying on my nail apron, the village inspector appeared and slapped a ten-dollar assessment on me for failing to take out a building permit. He wound up staying the morning, and we became friends. I met another neighbor who works odd hours but emerged to introduce himself one morning and offer me a fellow craftsman's praise. My wife and I decided that all couples should dispense with pre-marital counselling and try to build something together. If the relationship could withstand the rigors of carpentry, everything else would come easily by comparison.

During those seven dry weeks, I arose earlier and earlier each morning so I could water my tomatoes, my red-flowering cannas, my tea roses, and my grapes. They all survived the drought, somehow, even though my largest poplar and my smallest pear dehydrated in an ugly display of dried-up branches and drooping limbs. I survived, too, grieving a little over the deconstruction in my life (all those unanswered letters and phone calls, all those unfinished manuscripts and unread books). But I simultaneously rejoiced in the new constructions I discovered in my own life, the freshness and originality of vision I brought to my old job where burnout is visible on far too many faces. After tackling a scorching roof in plus-100-degree heat, even the dullest freshman student becomes a pure delight. How much easier it is now to accept the unacceptable, to meet the broken, the uneven, the out-of-line with patience and craftsmanship, to understand that the work is never really finished.

As I write, there is a subtle bite of coolness in the air, and fall surely approaches. I must leave the books (if only for a day), put in those storm windows and nail down that special weatherstripping for the storm door. How I love all this construction and deconstruction, the place I make with my own hands and the generous help of my spouse, the days that grow in pleasure and strength precisely because there is always something more to do.

Cover photograph by Raymond Bial, Urbana, Illinois
Typesetting by Precision Graphics, Champaign, Illinois
Printing and binding by Crouse Printing and Mailing Service, Champaign, Illinois